VIEWS

BEST OF THE NORTHWEST

Greg Adler

EMERALD POINT PRESS

▲

ISBN 0-9637816-6-9
Copyright © 2000
Emerald Point Press, Seattle, Washington
Library of Congress Control Number 00-090766

Printed in Hong Kong

"In God's wildness lies the hope of the world—the great, fresh, unblighted, unredeemed wilderness."

John Muir, 1890

*Middle Fork, Snoqualmie
River, Mountains to Sound
Greenway, Washington*

*The Trust for Public Land is the only national
nonprofit organization working exclusively to
protect land for human enjoyment and well-being.
TPL conserves land for recreation and spiritual
nourishment and to improve the health and quality
of life of American communities. TPL believes that
connecting people to land deepens the public's
appreciation of nature and their commitment to
protect it. Since its founding in 1972, TPL has helped
to protect more than one million acres in forty-five
states—from expansive recreation areas, to historic
homesteads, to pocket-sized city parks.*

*The Trust for Public Land's Northwest region encom-
passes six states, including Oregon, Washington,
Idaho, Montana, Wyoming and Alaska. Primary focus
areas are the Columbia Gorge National Scenic Area,
the Mountains to Sound Greenway, which runs along
Interstate 90 in Washington state, and the rapidly
growing Puget Sound and Portland Metropolitan
areas. From pristine wilderness such as Alaska's
Denali National Park and Montana's Lindberg Lake
to urban parks in Portland and Seattle, TPL has
protected nearly 160,000 acres in many of the
Northwest's most scenic places. Although these lands
are as varied as the Northwest landscape, they are all
vitally important to their communities and provide
significant benefit to people—Northwest residents
and visitors alike.*

*For further information about The Trust for Public
Land and programs near you, please contact our
website at www.tpl.org.*

Darkness shrouds the Northwest and sunrise is still hours away. The penetrating cold easily permeates the layered clothing as it seeps its way between the folds and crevices of outerwear to finally chill and awaken its misty-eyed occupant. Thus begins another photographic journey. As I wrote this I was thinking about the time and effort this collection of photographs represents. Most photographers I know work hard to create their images. They're persistent individuals willing to rise well before dawn, hike the trails in the dead of winter, or in some cases drop below the surface of the chilly Puget Sound, with the hope of being in the right place at the right time. We all know that when an opportunity presents itself we must be prepared to take advantage of it. They say that luck is when preparation and opportunity meet. In that context, these photographers were very lucky indeed.

These images are the results of a photographic competition sponsored by Emerald Point Press and benefiting The Trust for Public Land. Both the entry fees for the competition as well as a portion of the sale of this book support this worthwhile organization. As you view these photographs and appreciate their visual beauty think also of the talent and time involved. The photographer enjoys the process but I understand and appreciate the work and time it takes to develop the necessary skills. I hope you do as well.

These photographs should also remind us of how blessed we are with our natural landscape and the heritage entrusted to us to preserve the remaining wilderness for ourselves and future generations. To quote Wallace Stegner, "Something will have gone out of us as a people if we ever let the remaining wilderness be destroyed. We need wilderness preserved, because it was the challenge against which our character as a people was formed."

Please enjoy the Best of the Northwest.

Greg Saffell
Publisher

BEST OF THE NORTHWEST
ONE HUNDRED PHOTOGRAPHS

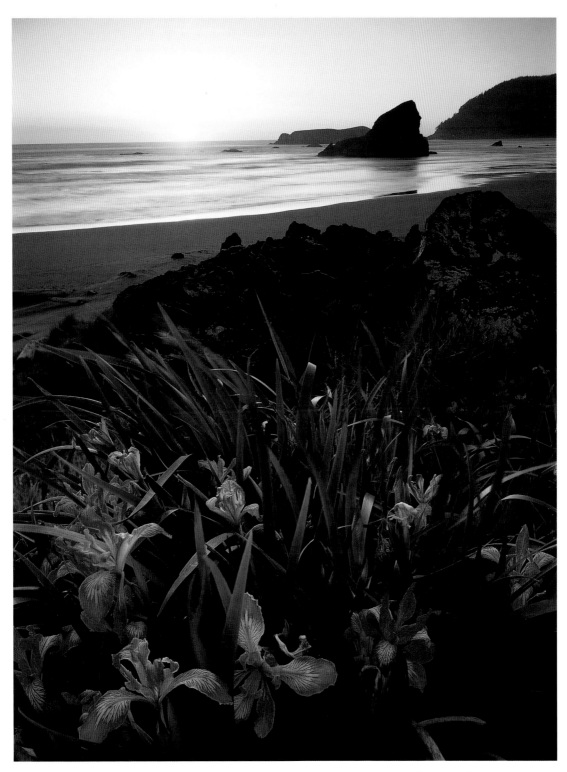

Chris Hauth

Wild Iris, Southern Coast, Oregon

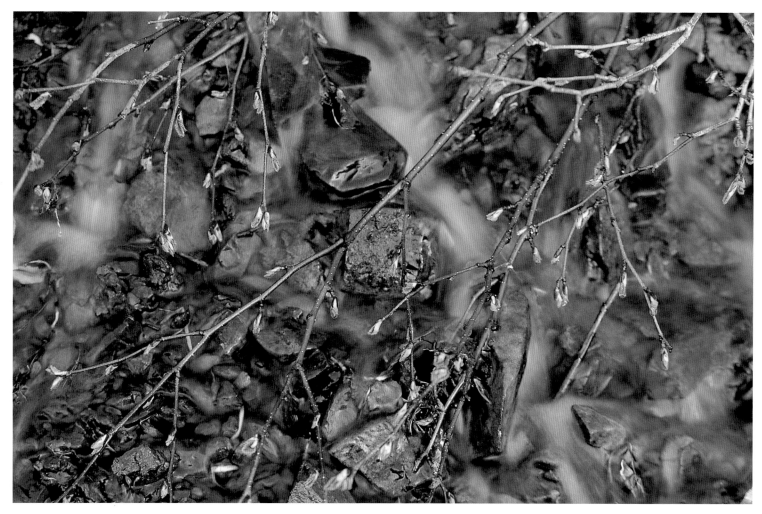

Shellye Poster

Snowmelt on Rocks, Olympic National Park, Washington

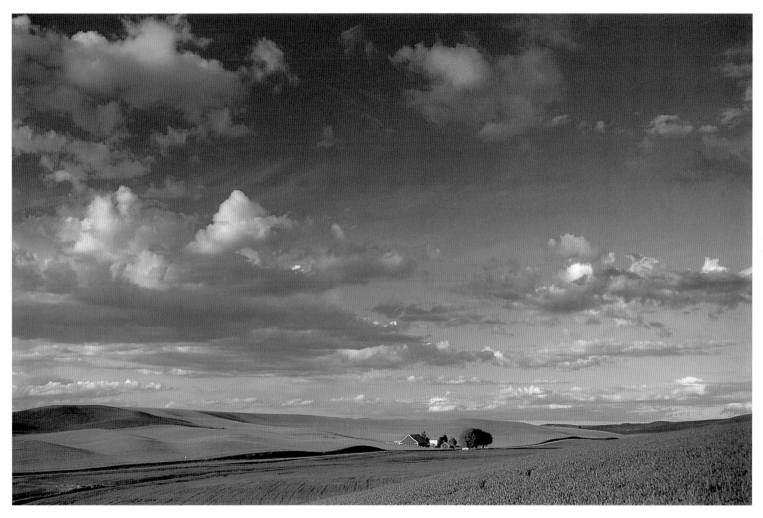

Burns Petersen

Palouse Sky, Eastern Washington

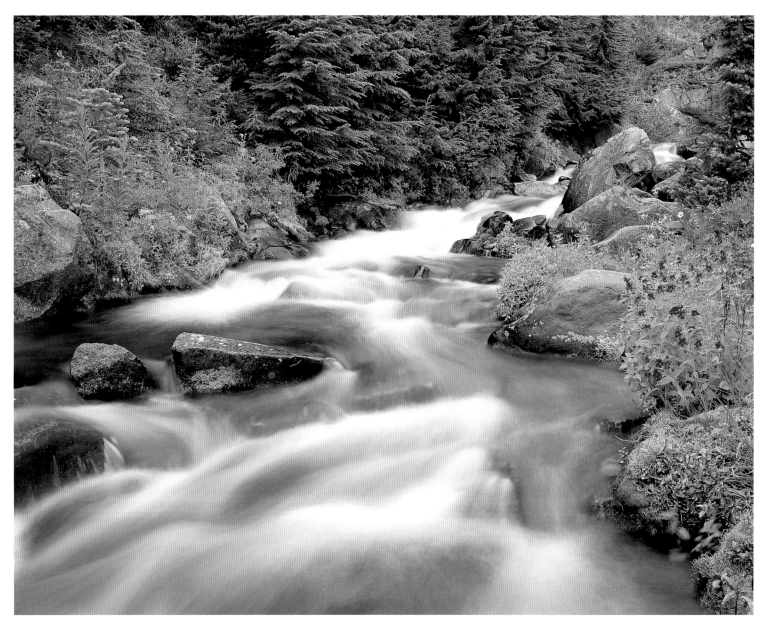

Mark Windom *Paradise River, Mount Rainier National Park, Washington*

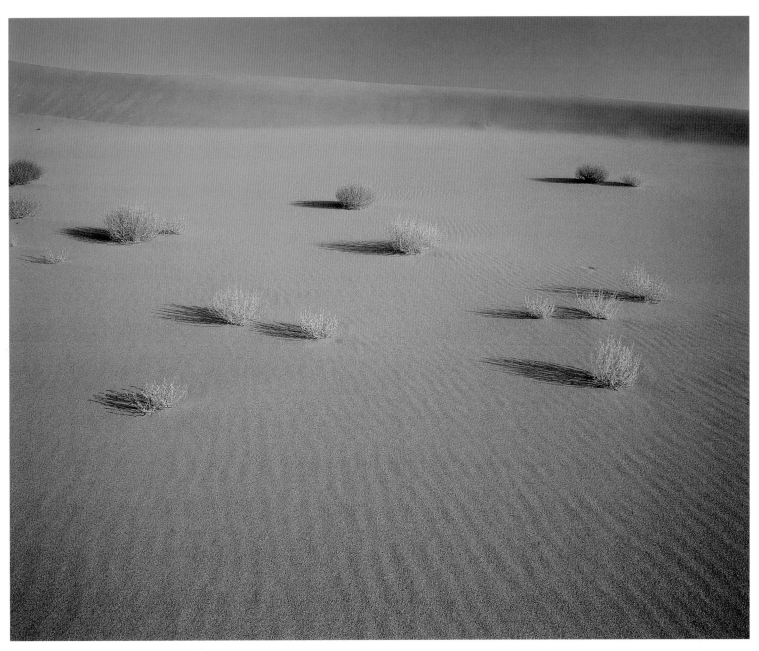

Dale Longendyke

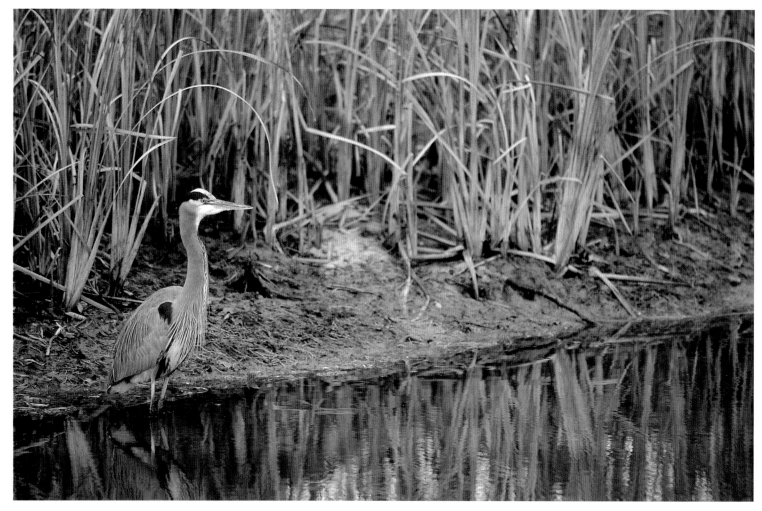

Jeff Hathaway

Great Blue Heron, Idaho

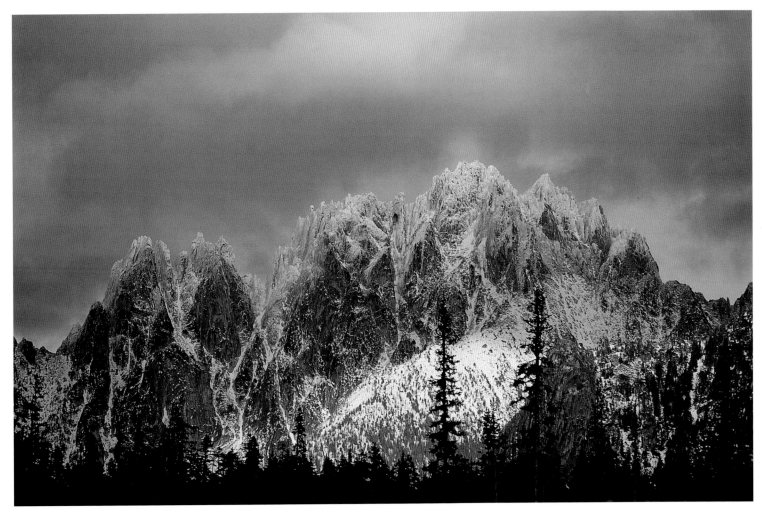

John Chao

Spires at Star Mountain, North Cascades, Washington

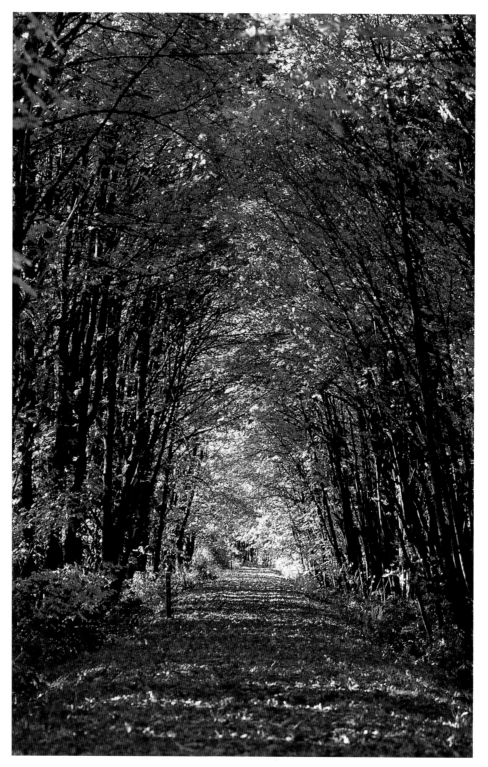

Craig Moore

Snoqualmie Valley Trail near Carnation, Washington

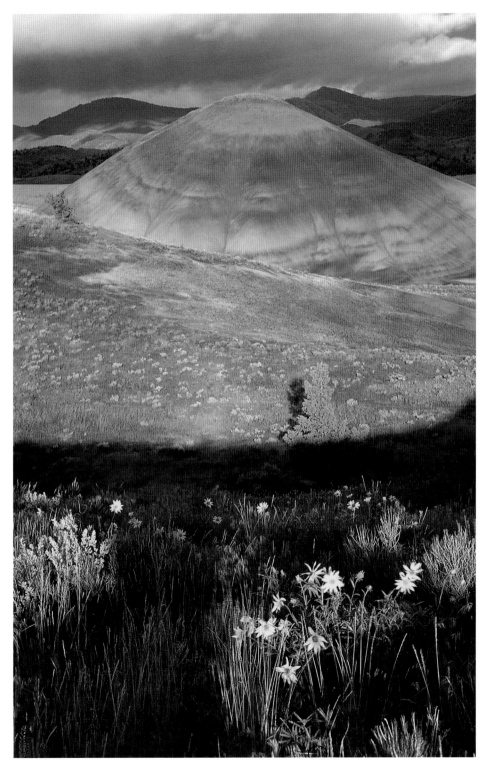

Ted Case *Painted Hills, John Day Fossil Beds National Monument, Oregon*

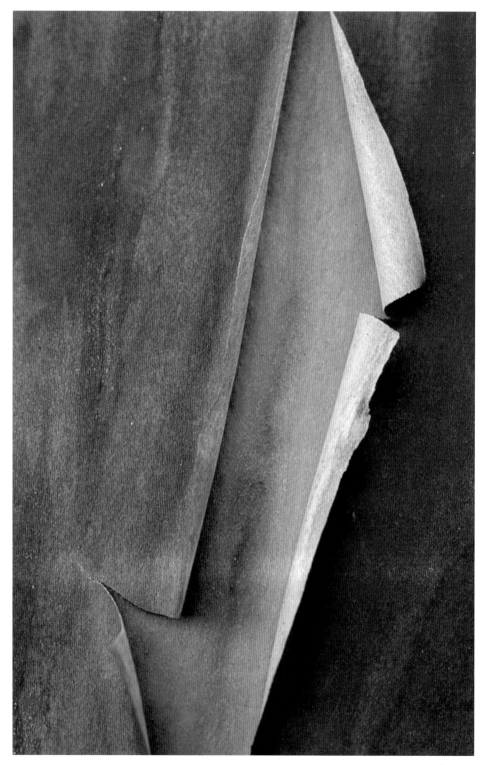

Ineke deLange

Pacific Madrone, Southern Oregon Coast

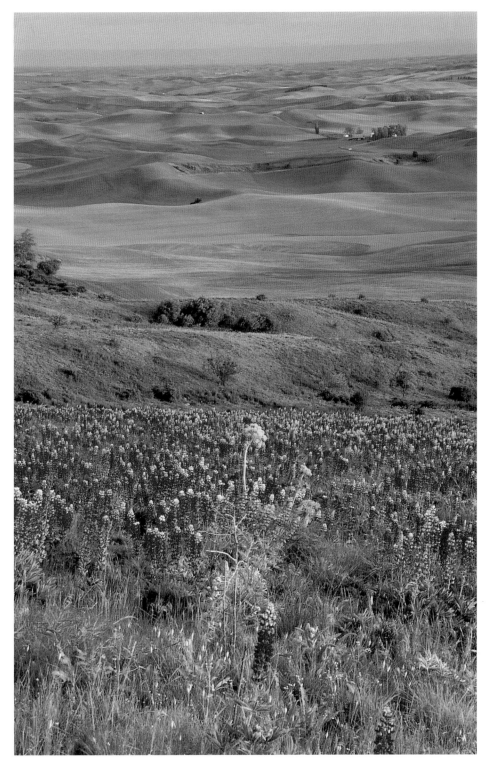

Connie Jacobson *Steptoe Butte, Palouse Region, Eastern Washington*

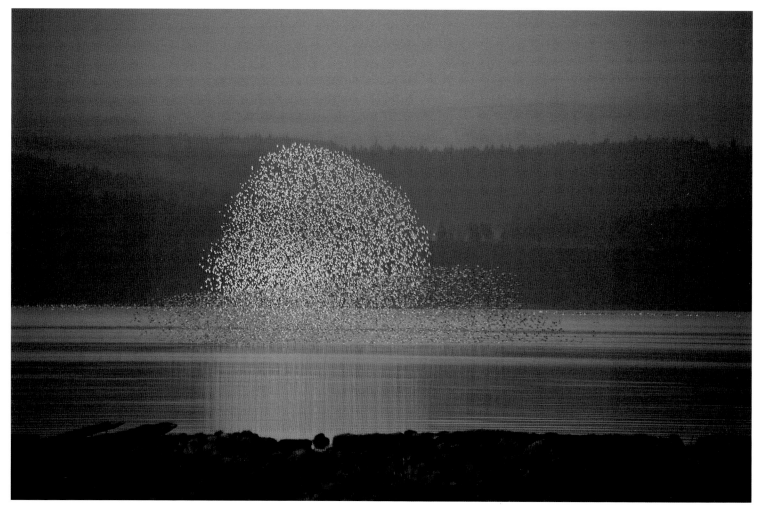

Joe Poehlman

Western Sandpipers, Skagit Bay, Washington

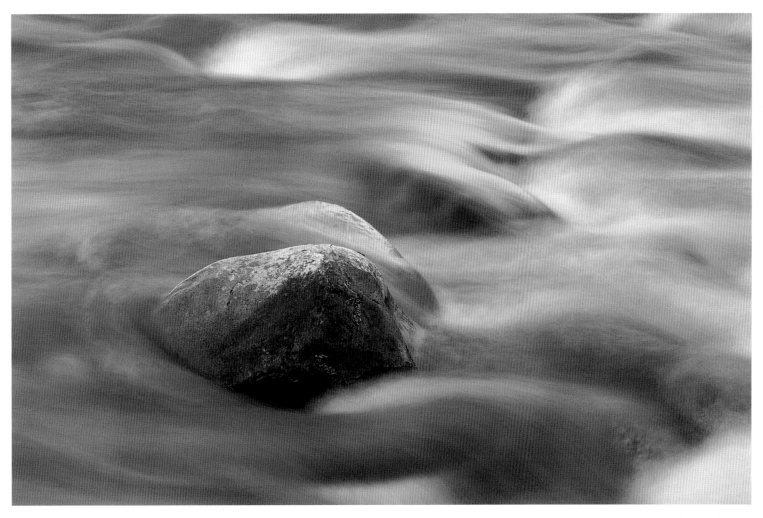

Stephen Matera

Nason Creek, Central Cascades, Washington

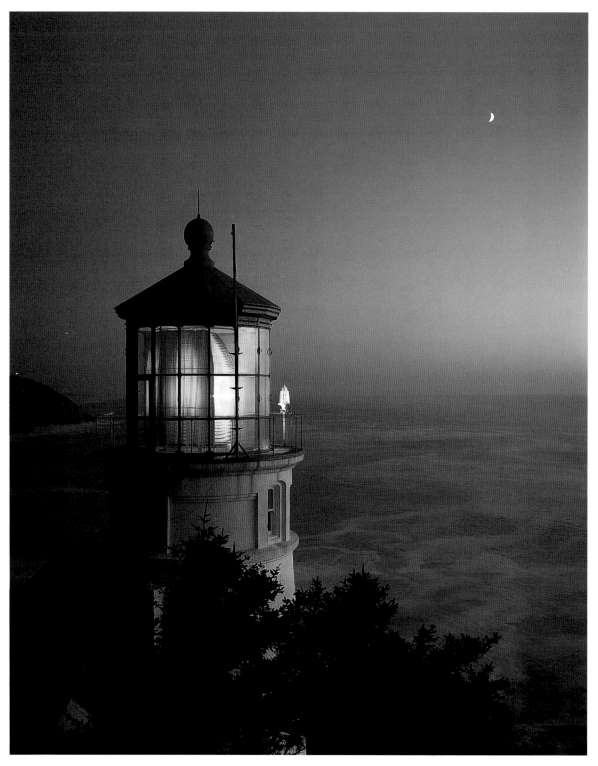

Mark Windom *Heceta Head Lighthouse, Oregon*

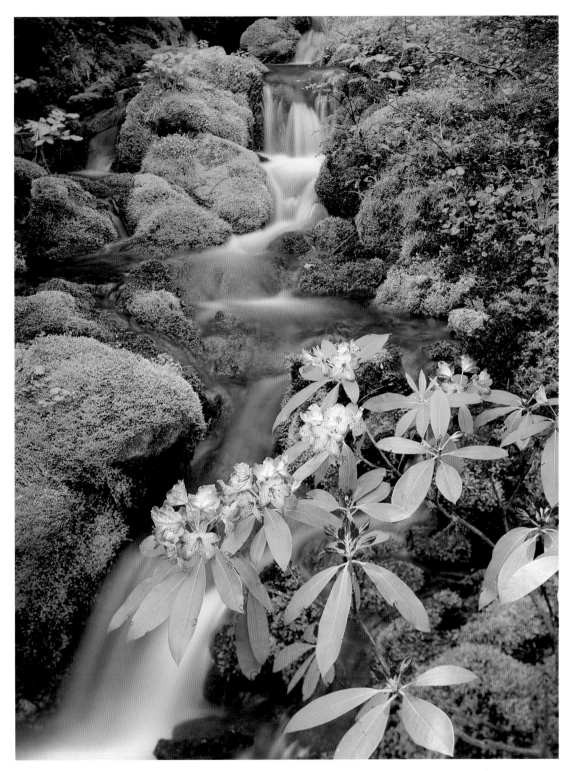

Chris Hauth

Rhododendron, Mount Hood National Forest, Oregon

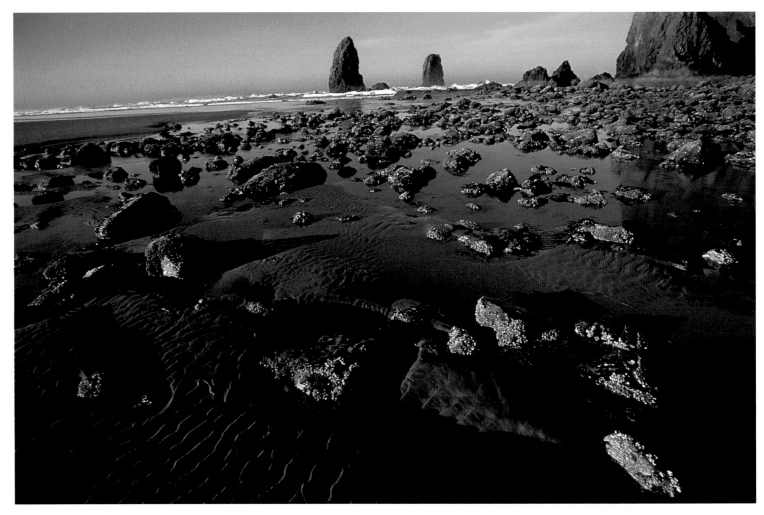

Nancy Ross

Cannon Beach, Oregon

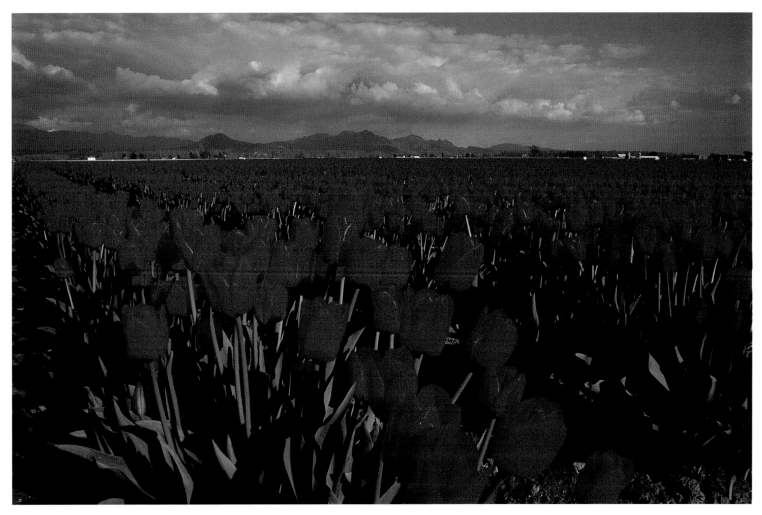

Slavomir Dzieciatkowski　　　　　　　　　　　　　　　　　　　　　　　*Tulips, Skagit Valley, Washington*

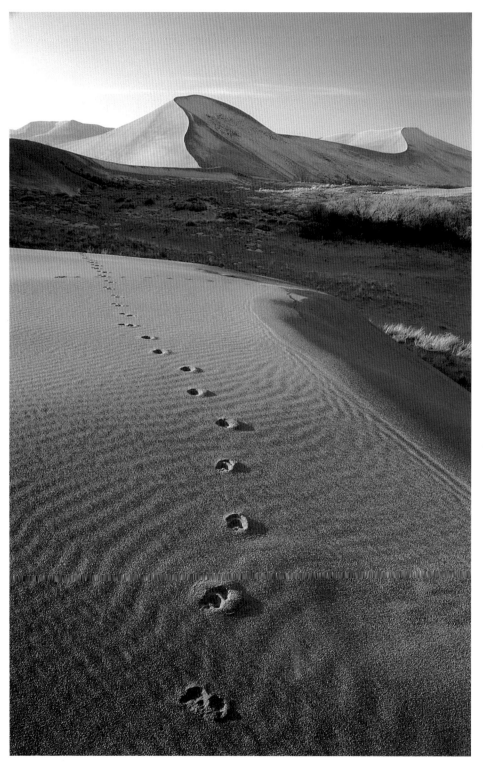

Daniel Kencke *Coyote Tracks, Bruneau Dunes State Park, Idaho*

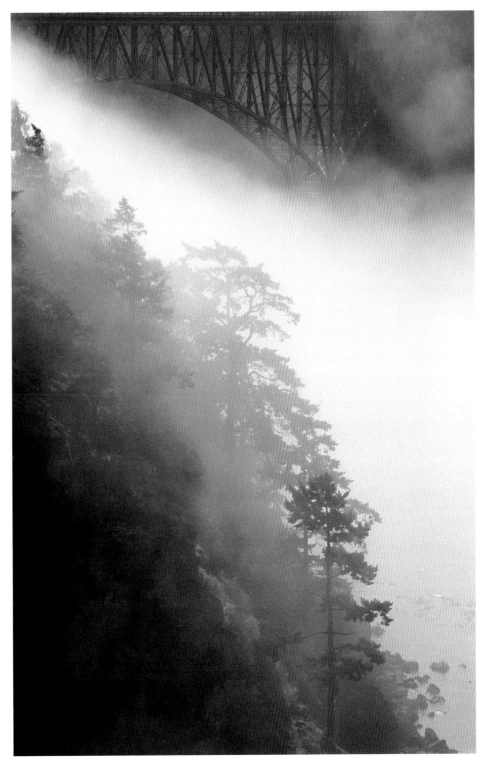

Deborah Kirsner *Deception Pass, Whidbey Island, Washington* 25

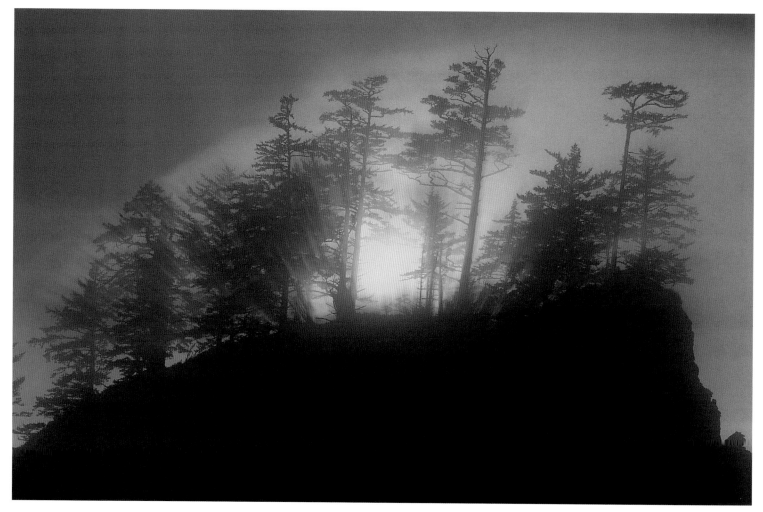

Stephen Matera

Lightbeams, Second Beach, Olympic National Park, Washington

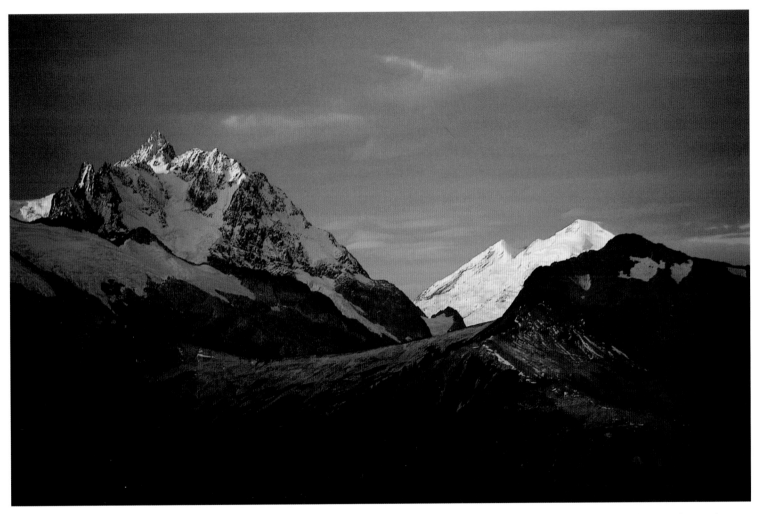

Carl Clark

North Cascades, Washington

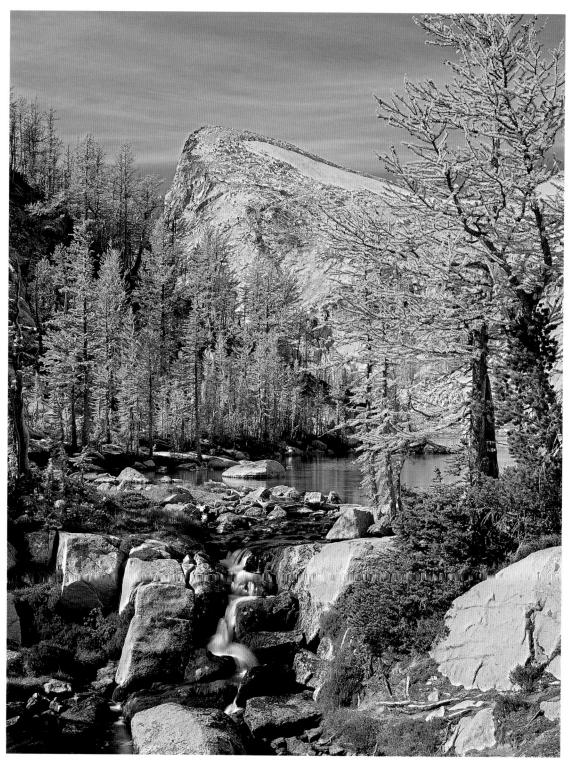

Greg Adler

Little Annapurna, Alpine Lakes Wilderness, Washington

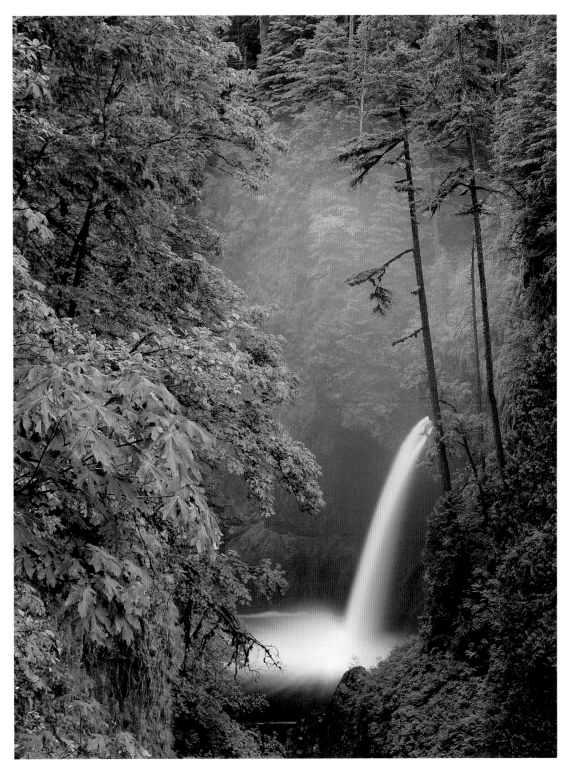

Chris Hauth

Metlako Falls, Columbia River Gorge, Oregon

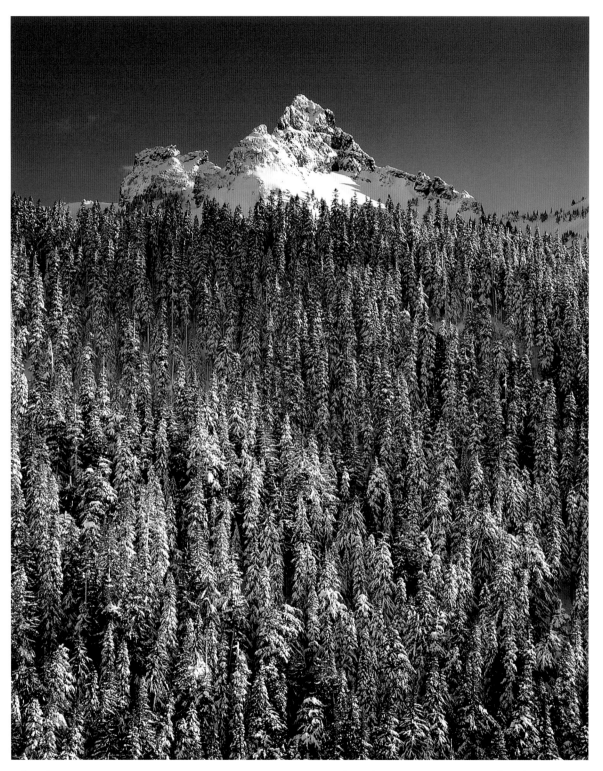

John Chao *Pinnacle Peak, Mount Rainier National Park, Washington*

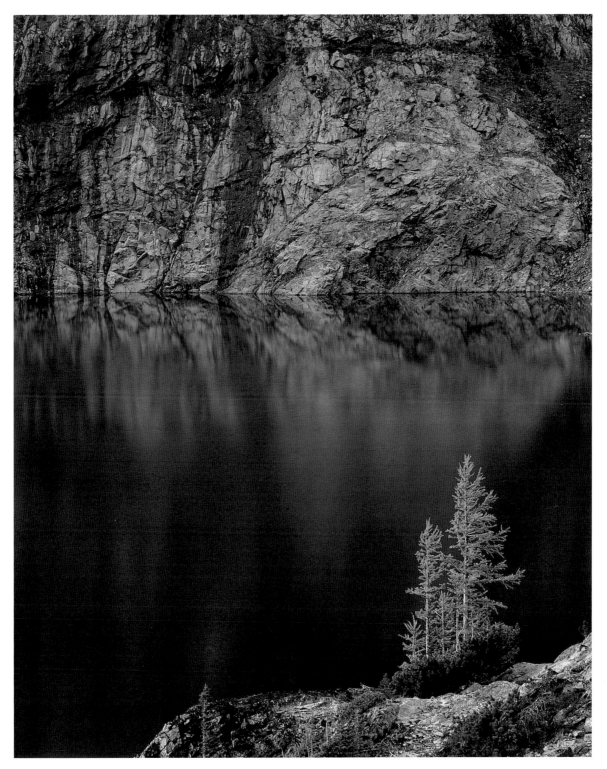

Dave Schiefelbein

Larch Trees and Upper Ice Lake, Glacier Peak Wilderness, Washington

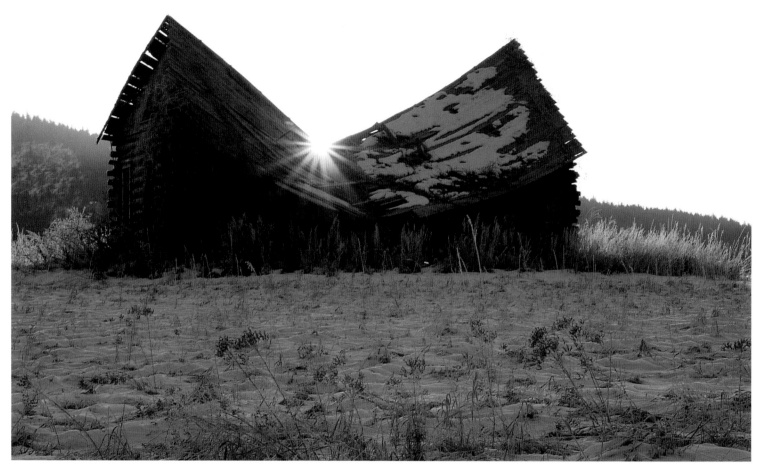

Paul Jacobson

School House, Worley, Idaho

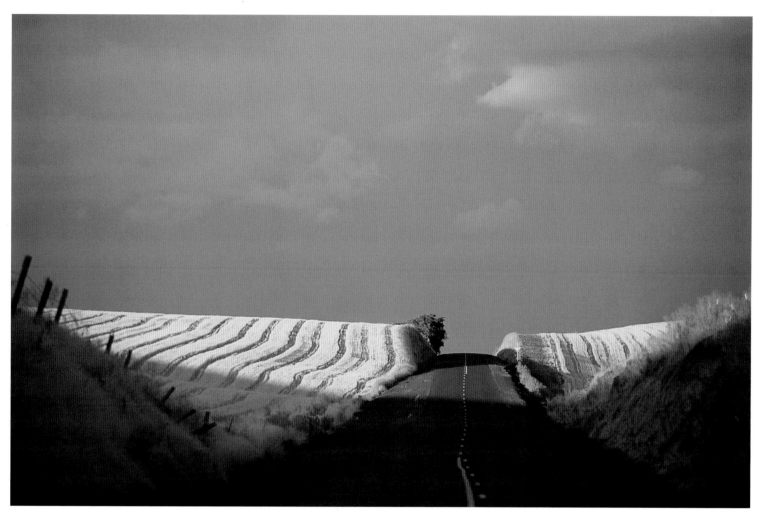

Andrew Buchanan *Middle Waitsburg Road, Eastern Washington*

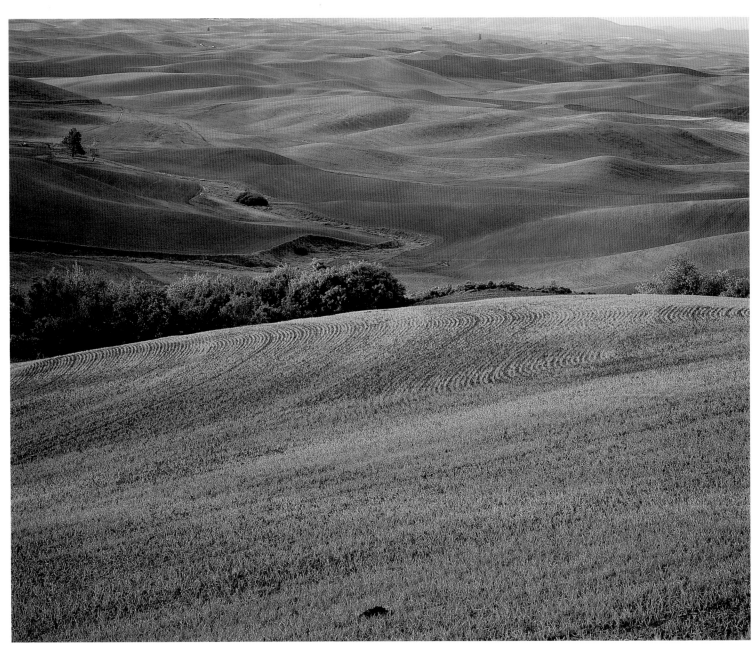

Jeffrey Miller

Palouse Region, Eastern Washington

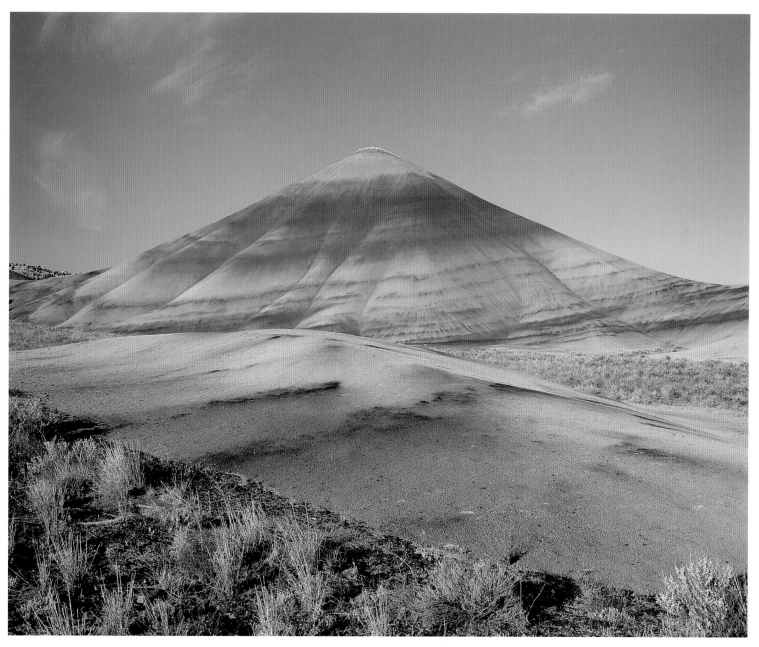

Dan Sage

Painted Hills, John Day Fossil Beds National Monument, Oregon

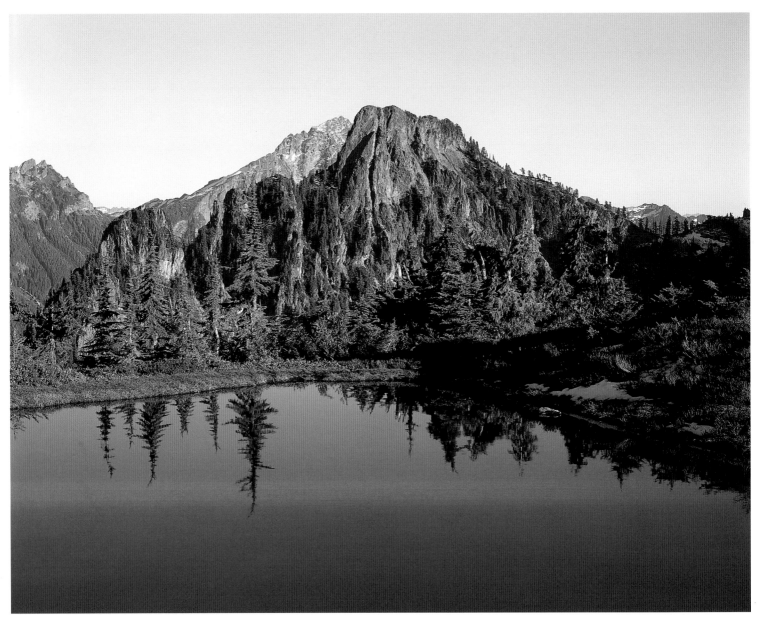

Greg Adler

Mount Forgotten Meadow, near Boulder River Wilderness, Washington

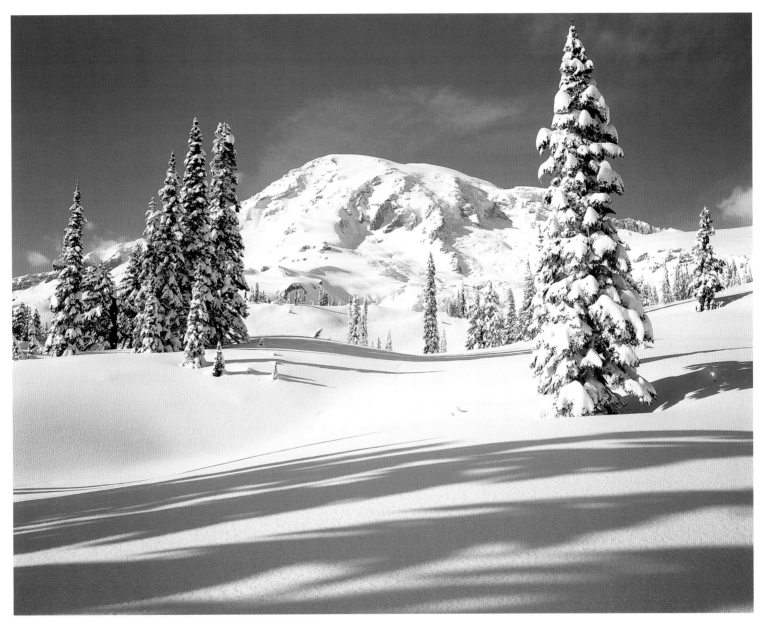

Mark Windom *Paradise in Winter, Mount Rainier National Park, Washington*

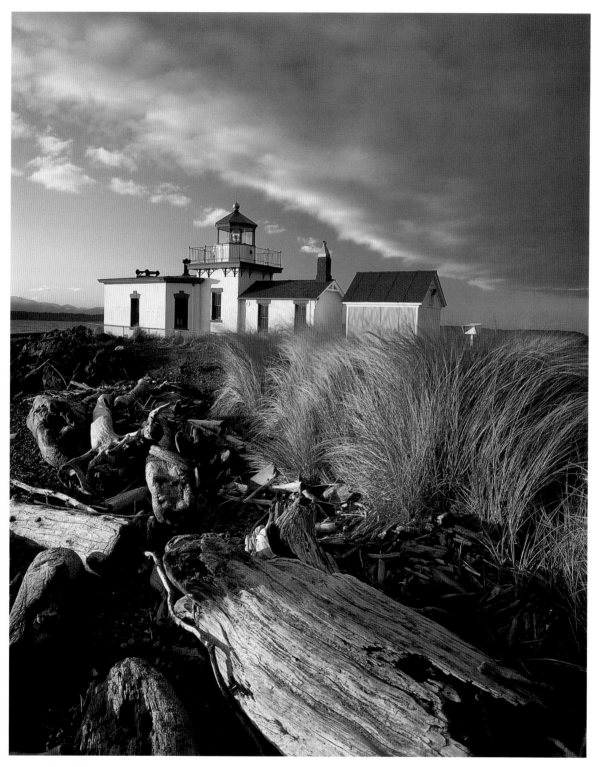

Dave Schiefelbein

Westpoint Lighthouse, Seattle, Washington

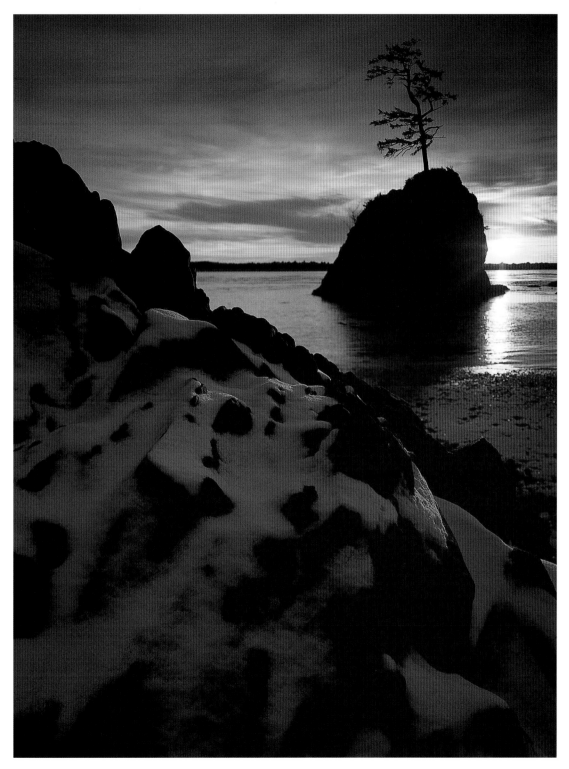

Chris Hauth

Rare Snow, Tillamook Bay, Oregon

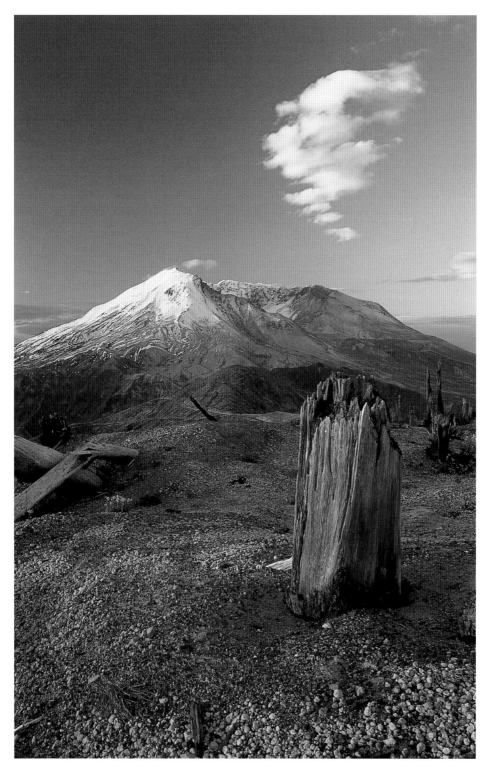

Daniel Kencke *Mount St. Helens, Mount St. Helens National Monument, Washington*

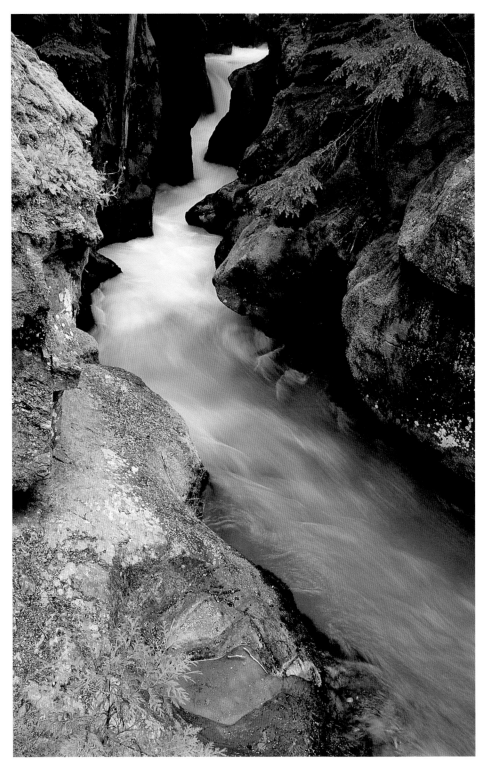

Shellye Poster *Avalanche Creek, Glacier National Park, Montana* *41*

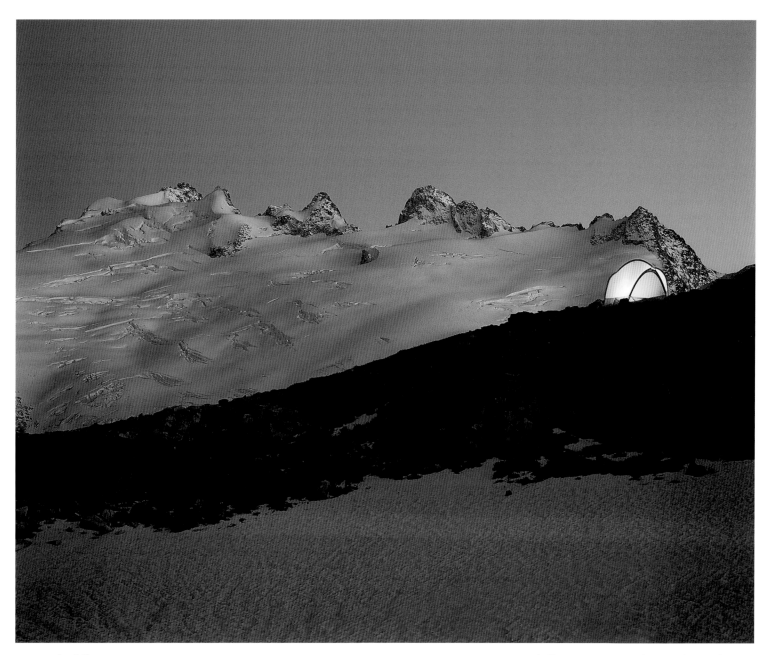

Dave Schiefelbein

Mount Challenger Camp, North Cascades, Washington

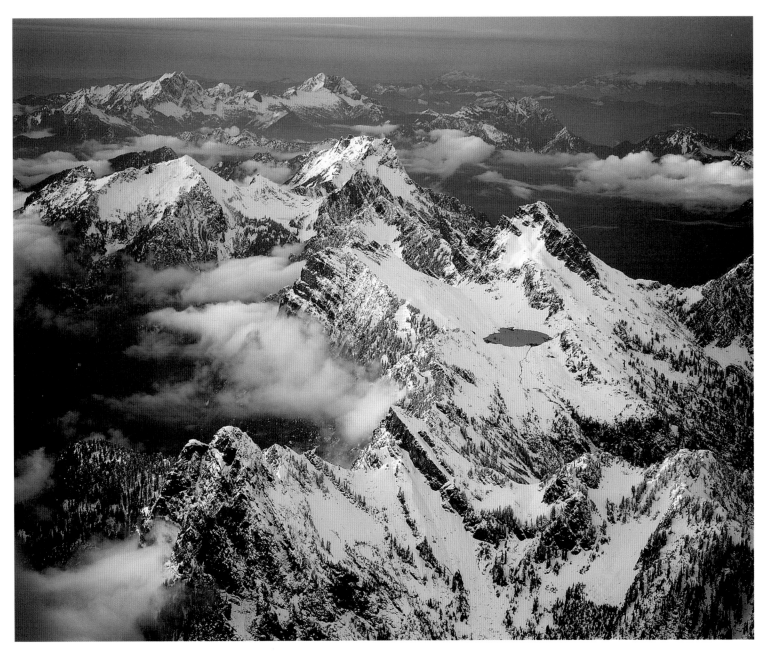

John Chao

Crater Lake, North Cascades, Washington

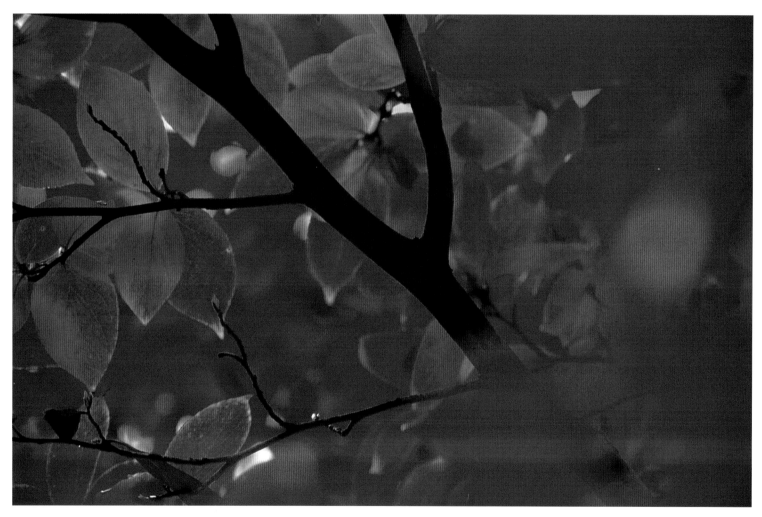

Nancy Ross

Autumn Leaves, Weyerhaeuser Botanical Gardens, Washington

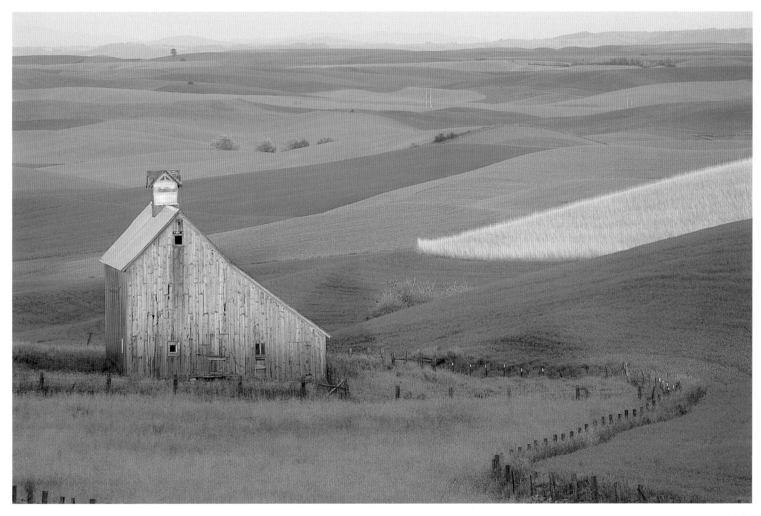

Gary Benson

Barn, near Moscow, Idaho

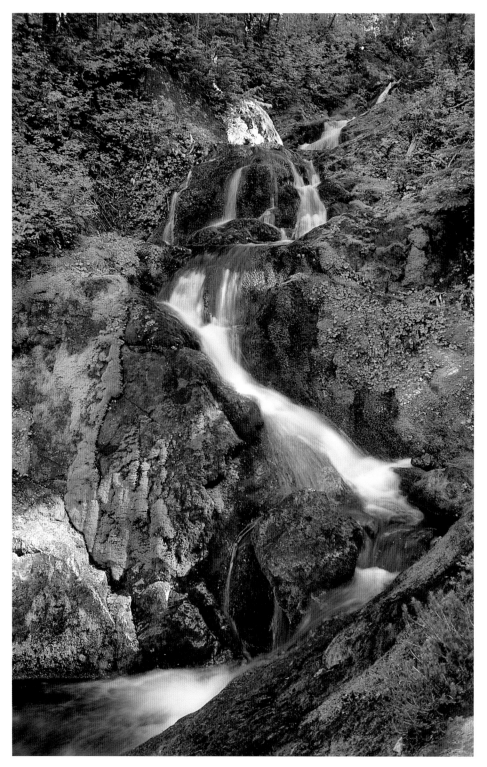

Greg Adler *Wonderland Trail, Mount Rainier National Park, Washington*

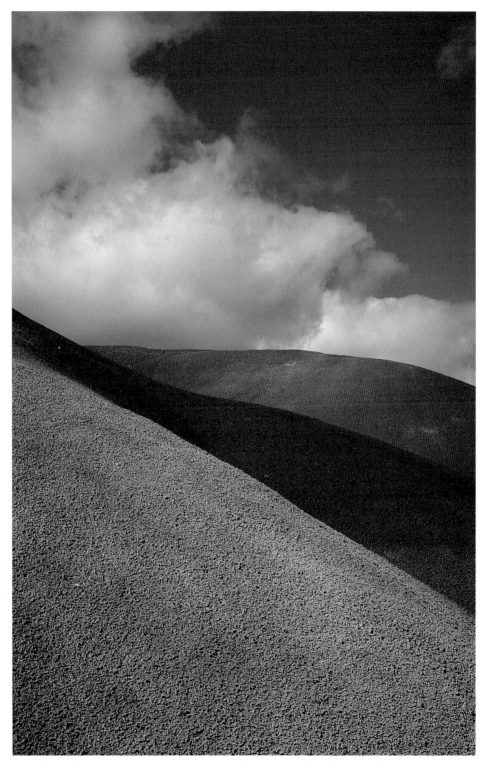

Daniel Kencke *John Day Fossil Beds National Monument, Oregon*

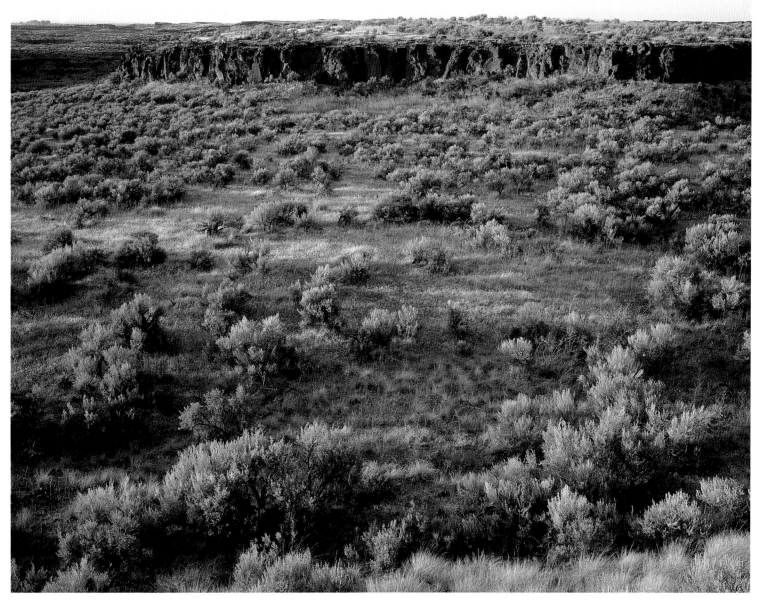

Nick Jahn

Sagebrush Field, Potholes Wildlife Area, Eastern Washington

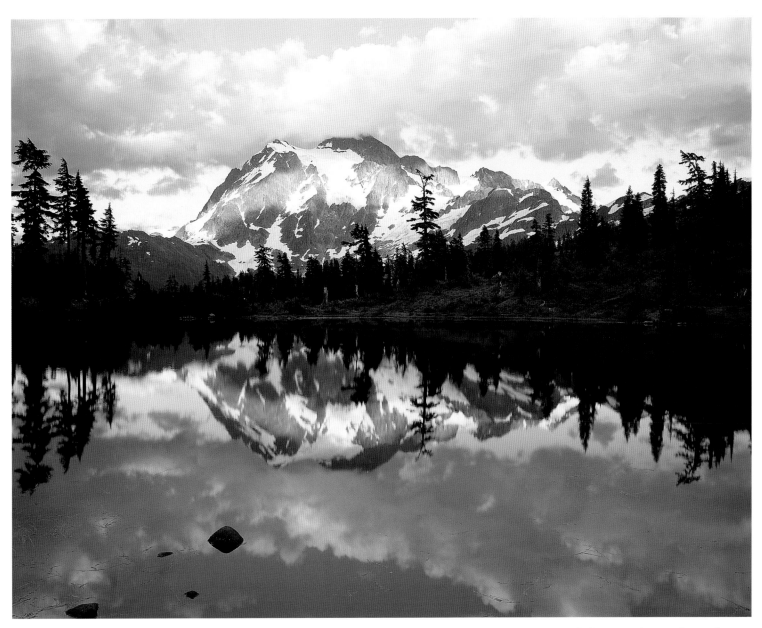

Mark Windom

Mount Shuksan, North Cascades, Washington

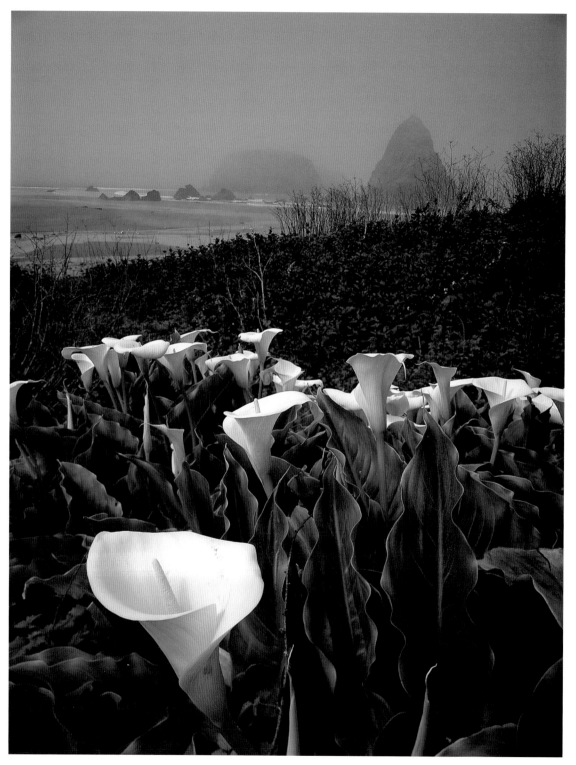

Chris Hauth *Calla Lily, Southern Coast, Oregon*

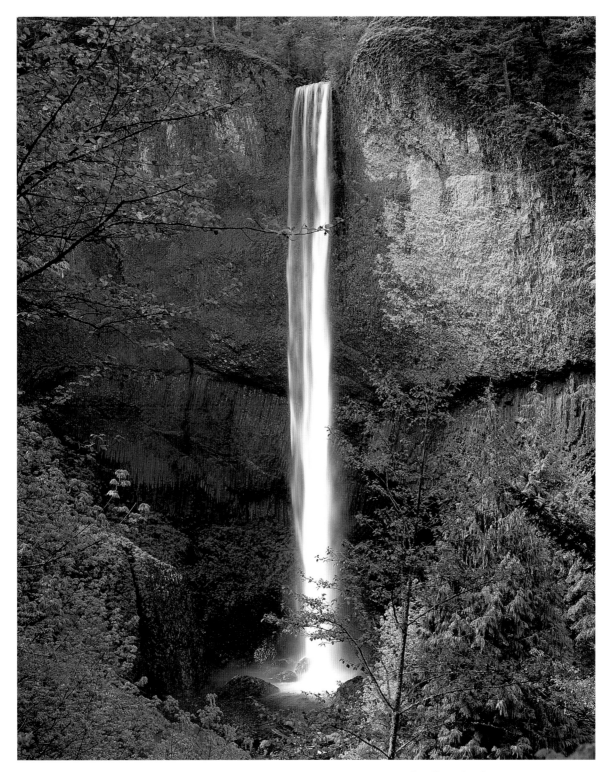

Dan Sage

Latourell Falls, Columbia River Gorge, Oregon

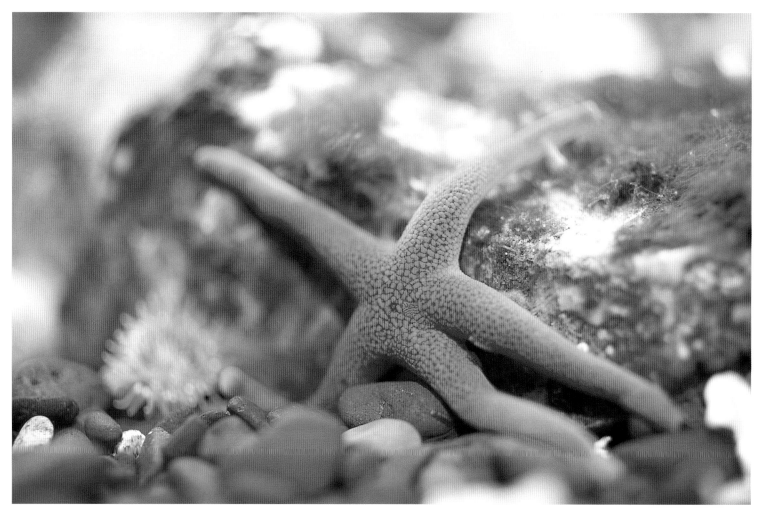

Basil Childers

Sea Star, Oregon Coast Aquarium, Oregon

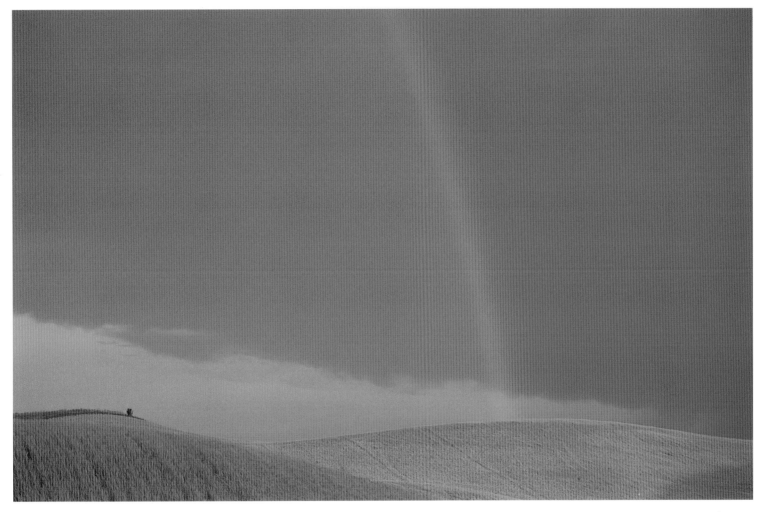

Gary Benson

Harvest Sunrise, Eastern Washington

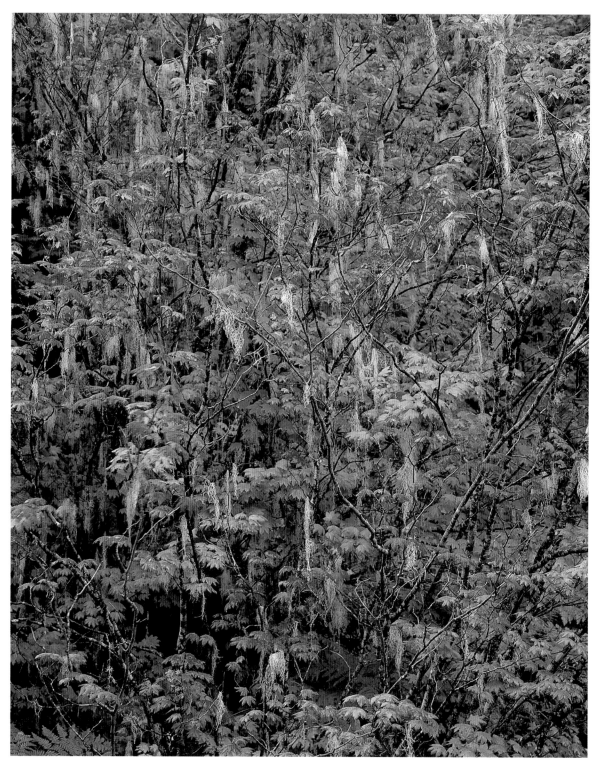

Dave Schiefelbein

Autumn, Mount Rainier National Park, Washington

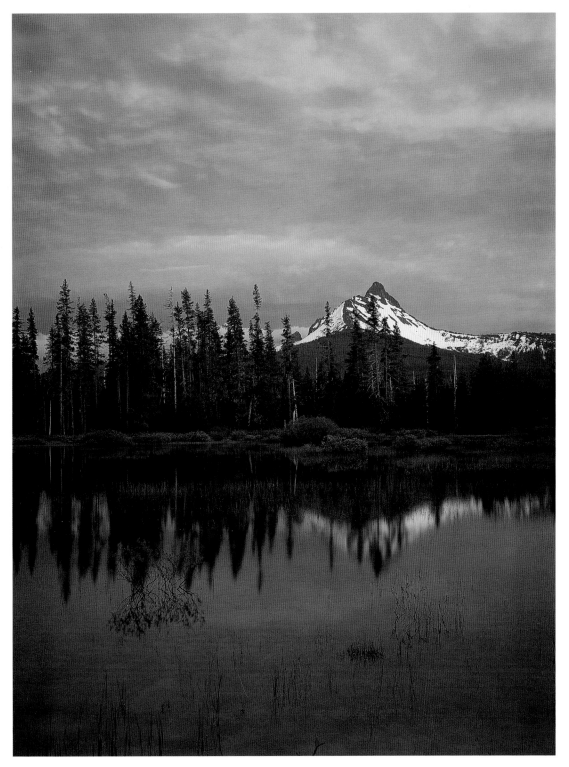

Chris Hauth

Mount Washington, Oregon Cascades, Oregon

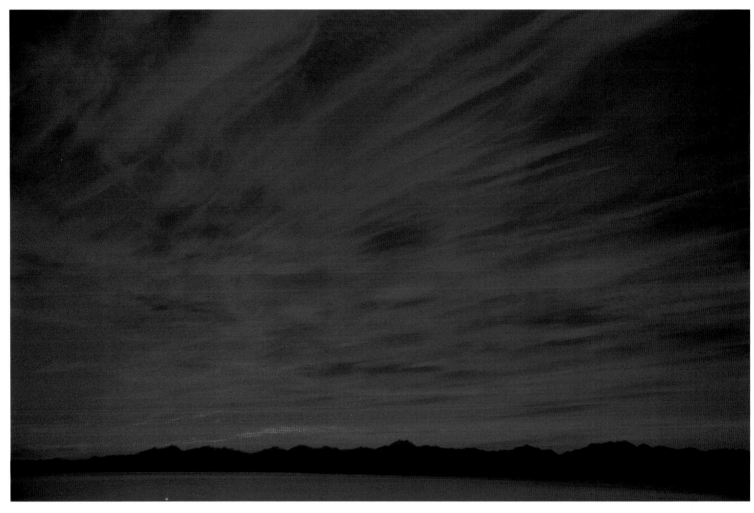

John Chao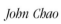 *Sunset, Puget Sound, Washington*

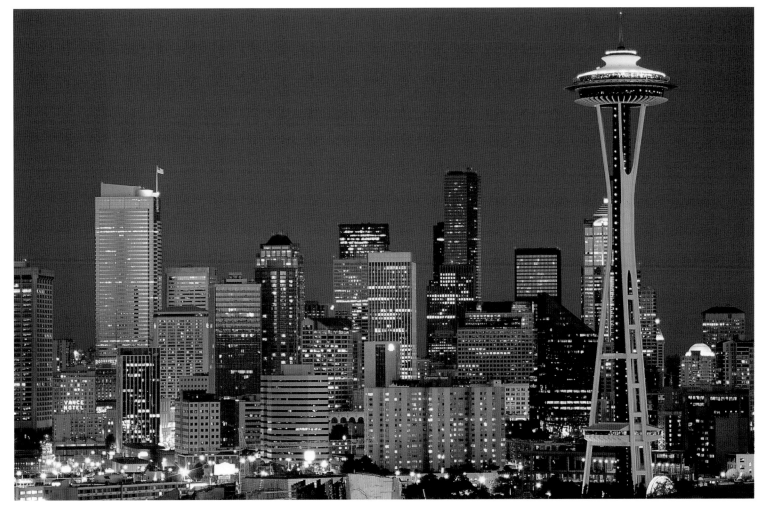

Craig Moore

Seattle Skyline from Queen Anne, Washington

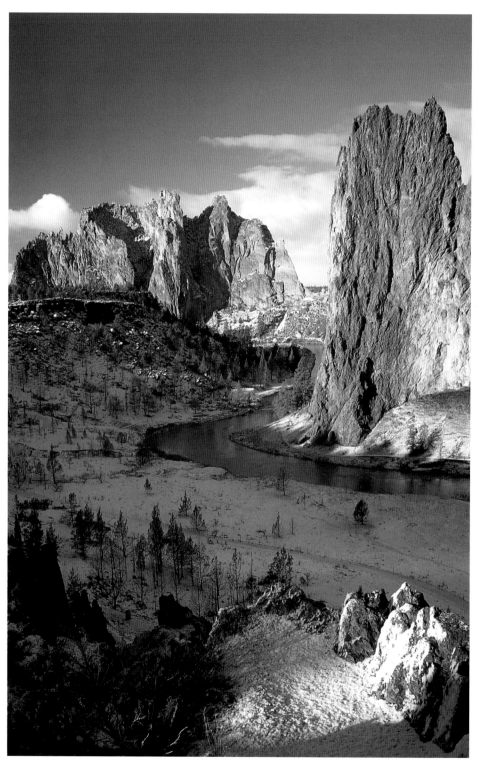

Joe Poehlman *Smith Rock State Park, Oregon*

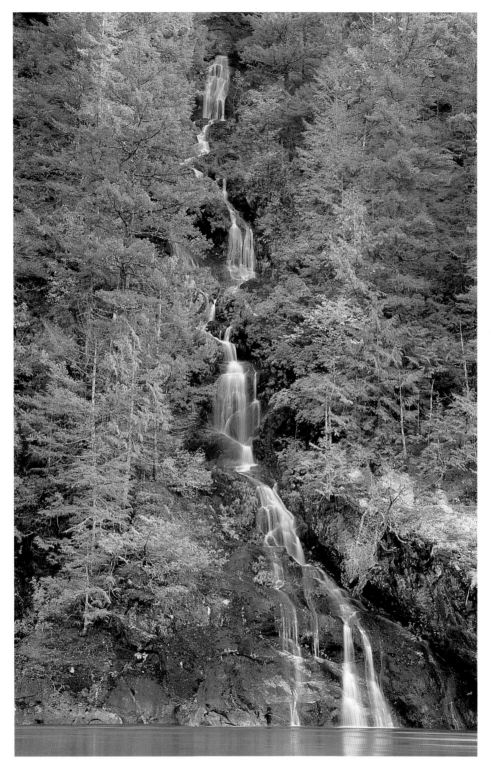

Terry Wallace *Newhalem Creek, Ross Lake National Recreation Area, Washington* *59*

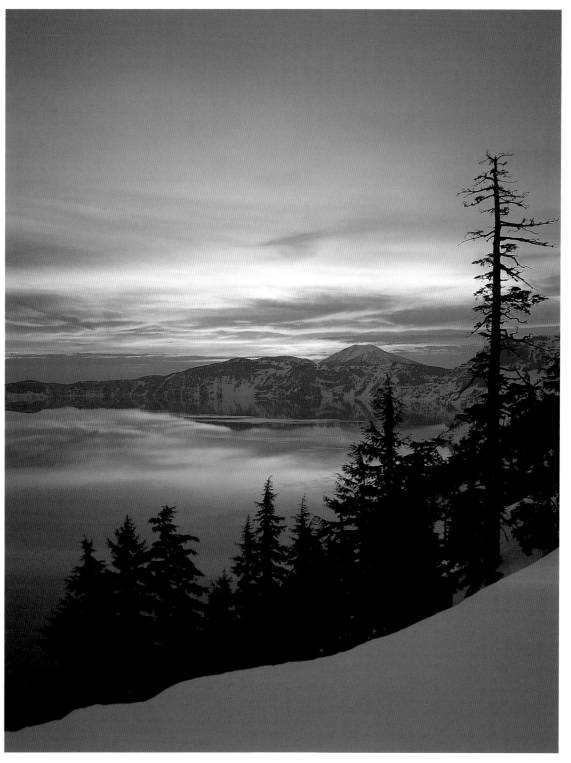

Chris Hauth

Crater Lake National Park, Oregon

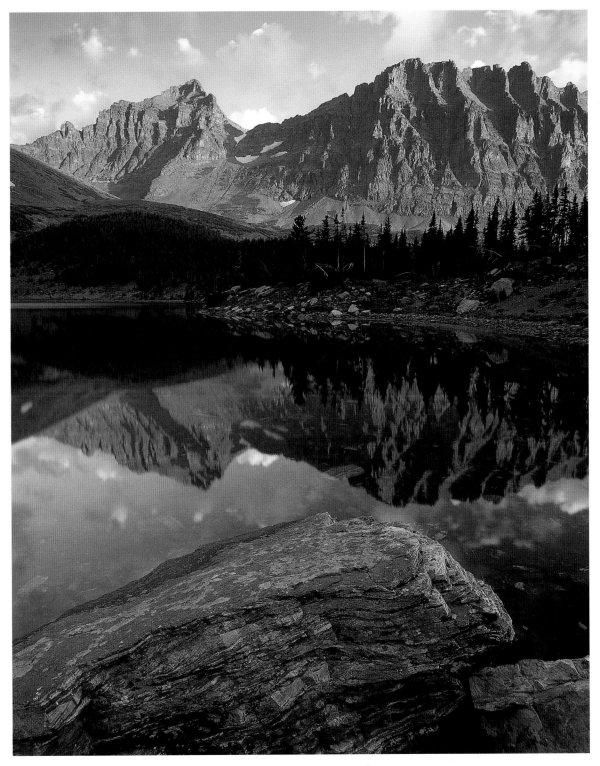

Stephen Matera

Mount Rockwell and Cobalt Lake, Glacier National Park, Montana

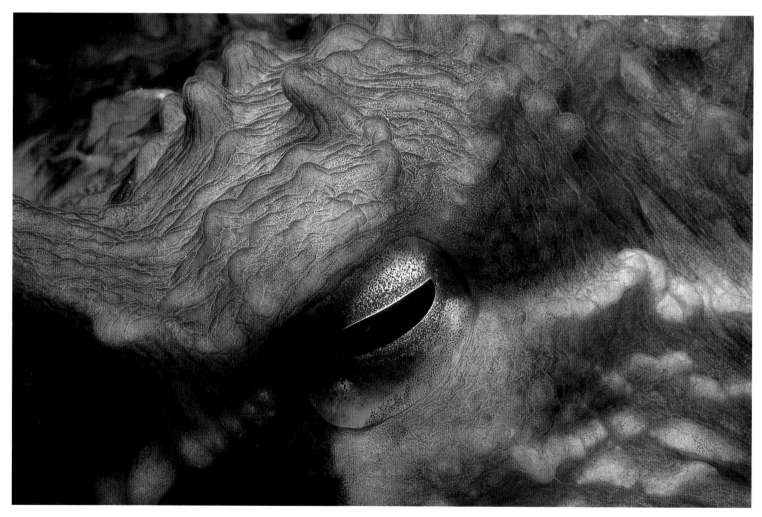

Katrina Kruse

Giant Pacific Octopus Eye, Puget Sound, Washington

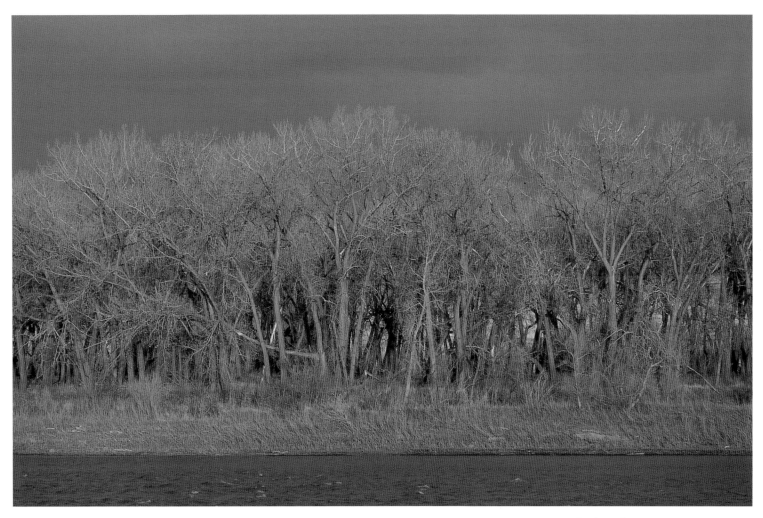

Craig Moore

Cottonwoods along the Missouri River, Montana

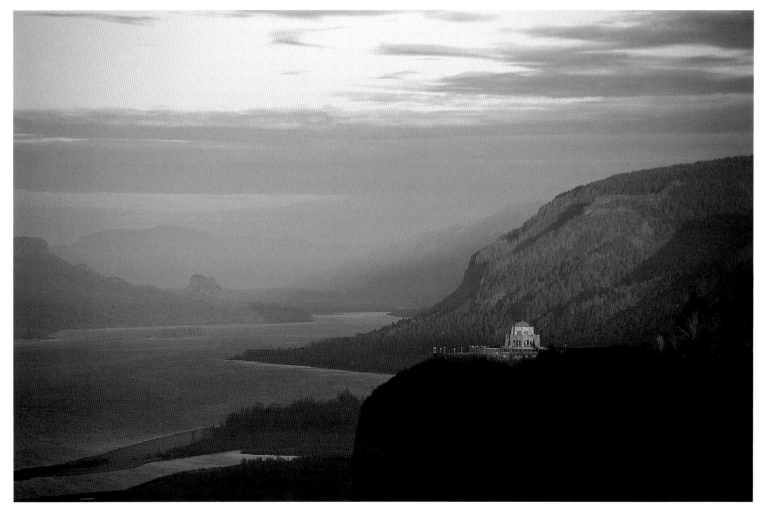

Carl Clark

Columbia River Gorge, Oregon

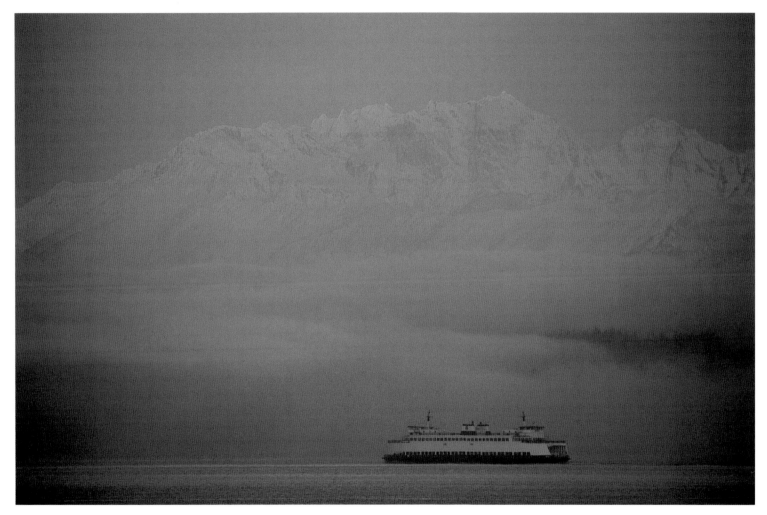

John Chao

Winter Crossing, Puget Sound, Washington

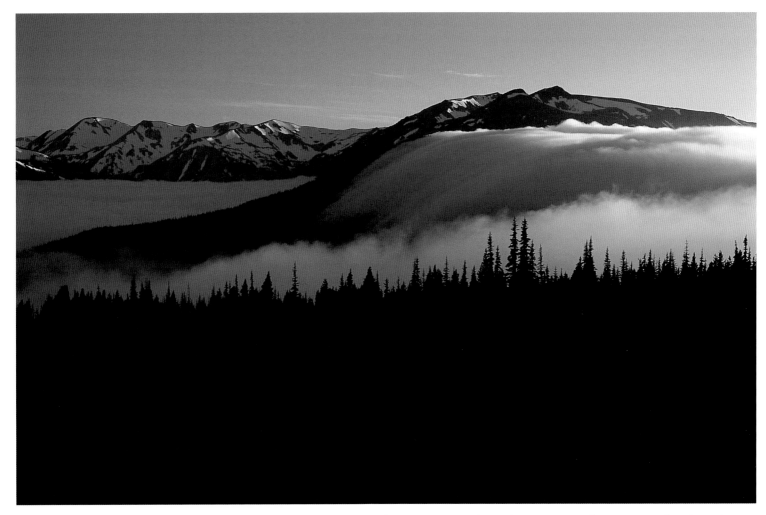

Stephen Matera

Olympic Mountains from Blue Mountain, Olympic National Park, Washington

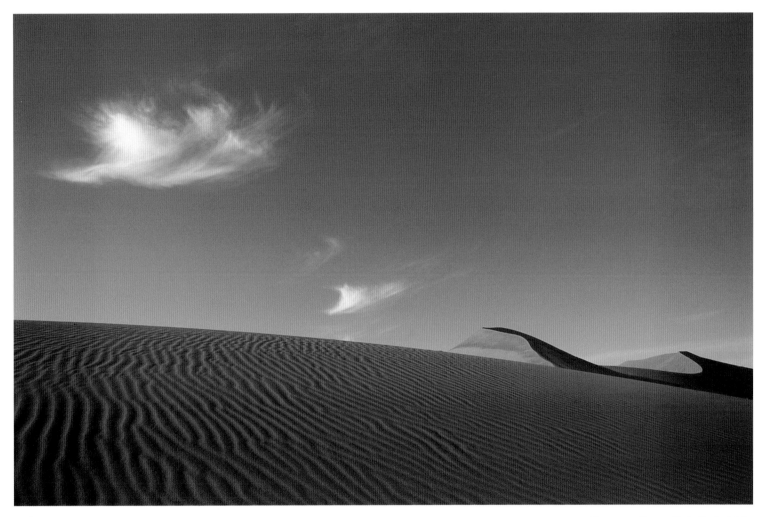

Ted Case

Bruneau Dunes State Park, Idaho

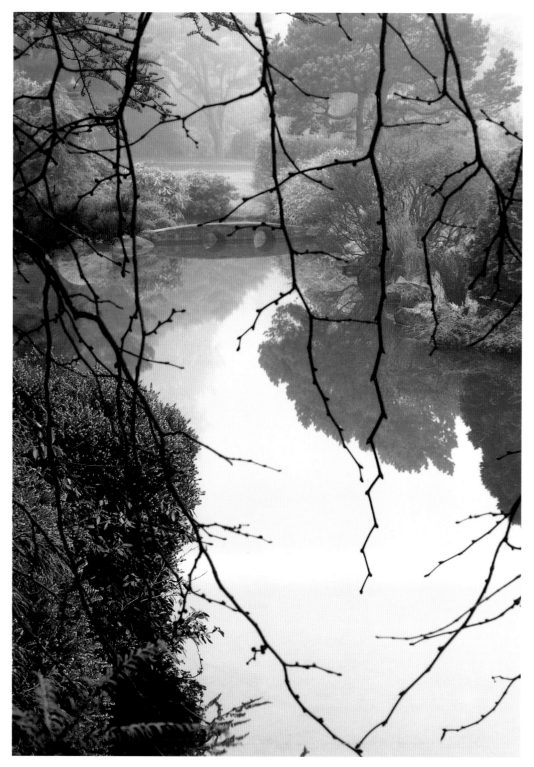

Bill Brooksher *Winter Morning, Kubota Gardens, Seattle, Washington*

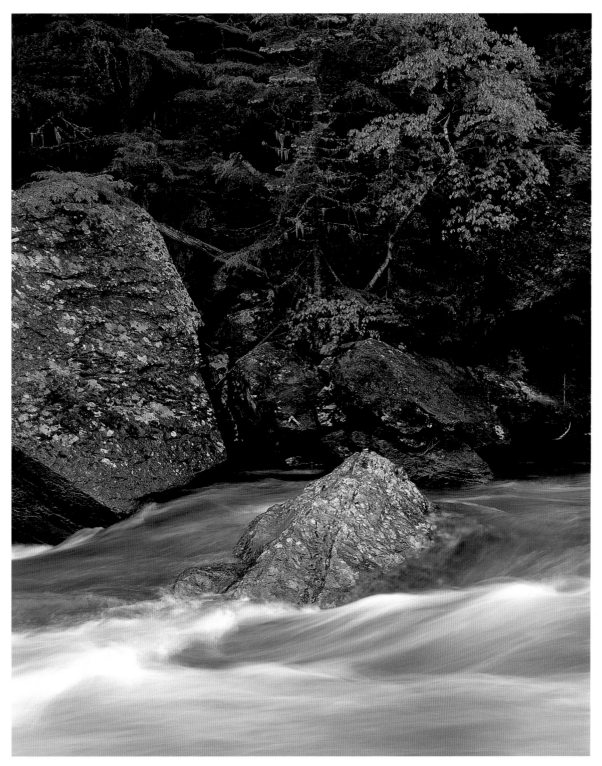

Dale Longendyke

McDonald Creek, Glacier National Park, Montana

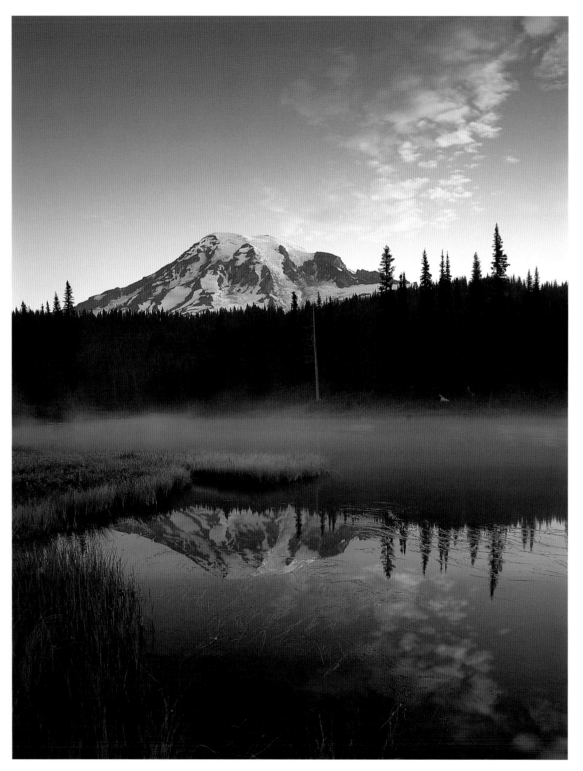

Chris Hauth

Mount Rainier, Mount Rainier National Park, Washington

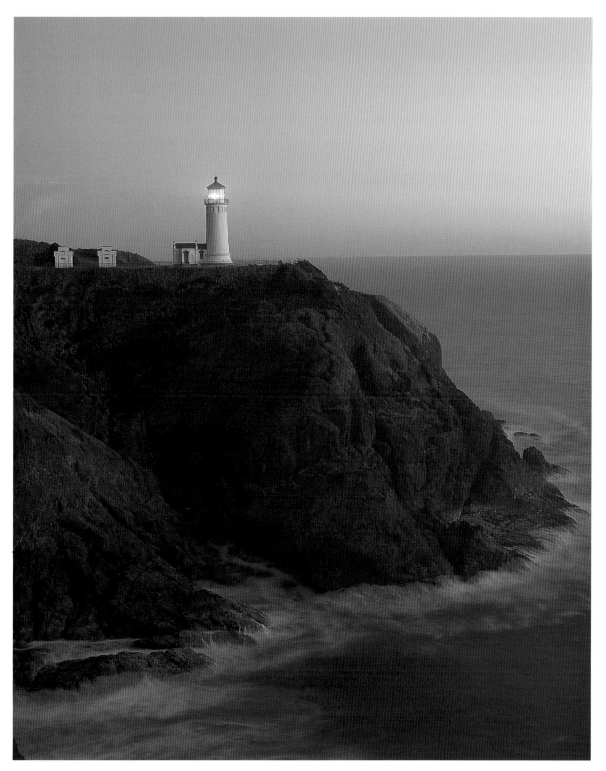

Mark Windom *North Head Lighthouse, Washington*

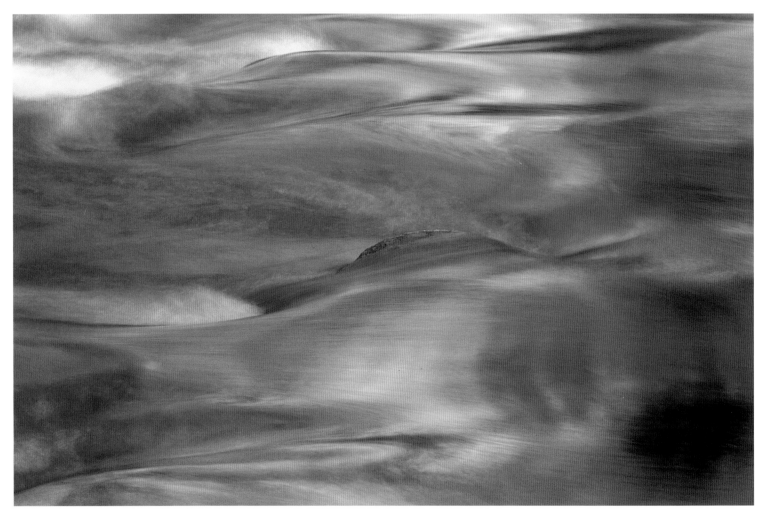

Daniel Kencke

Wenatchee River, near Leavenworth, Washington

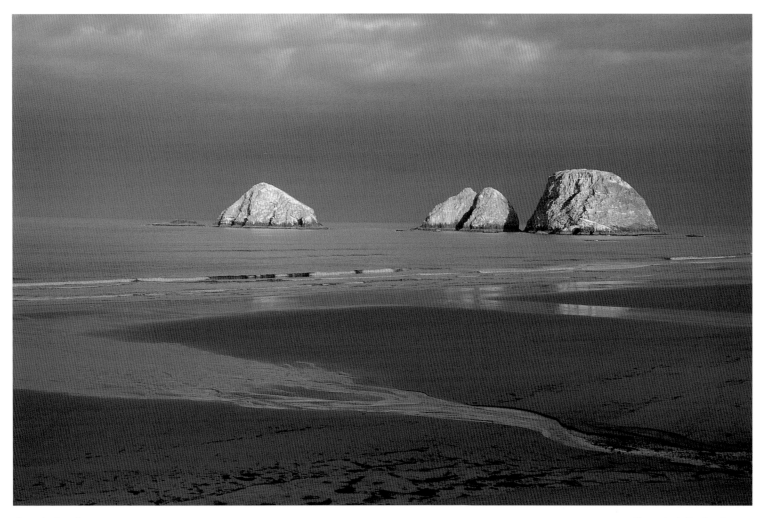

Connie Jacobson

Three Arch Rocks, Oregon

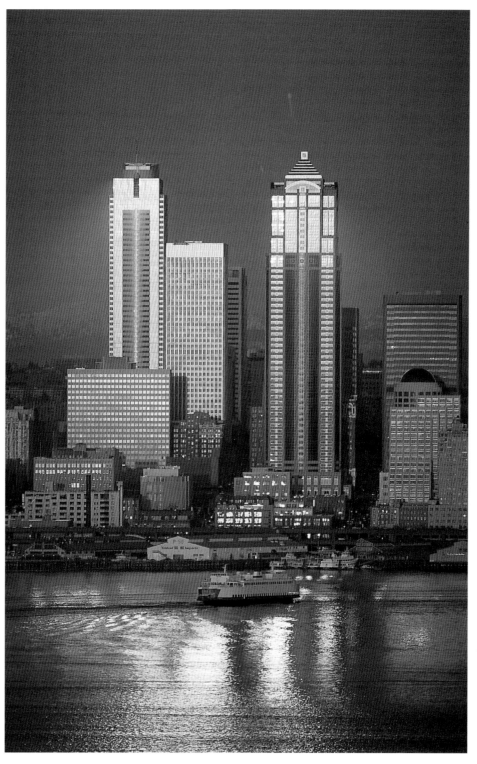

Gary Benson *Seattle Waterfront at Sunset, Washington*

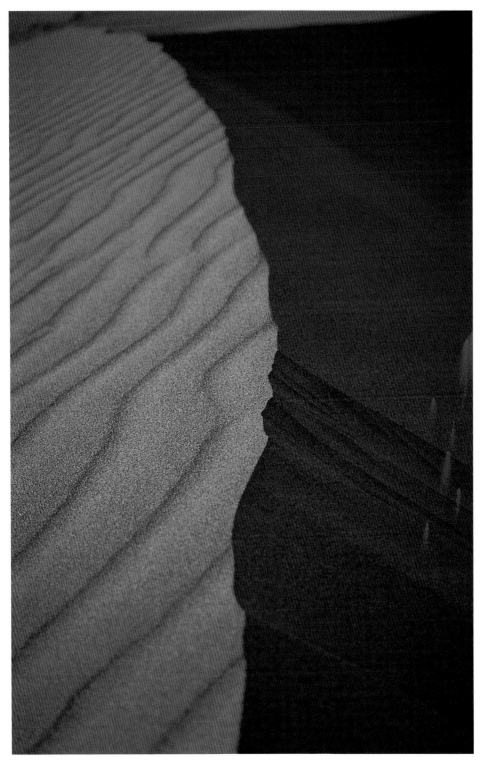

Jeff Hathaway *Bruneau Dunes State Park, Idaho*

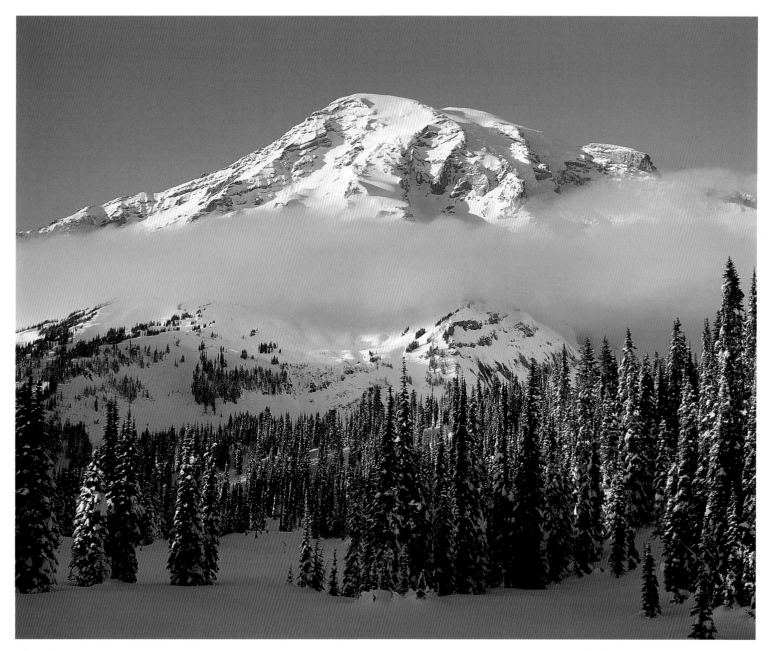

John Chao

Sunset Cloud at Mount Rainier, Washington

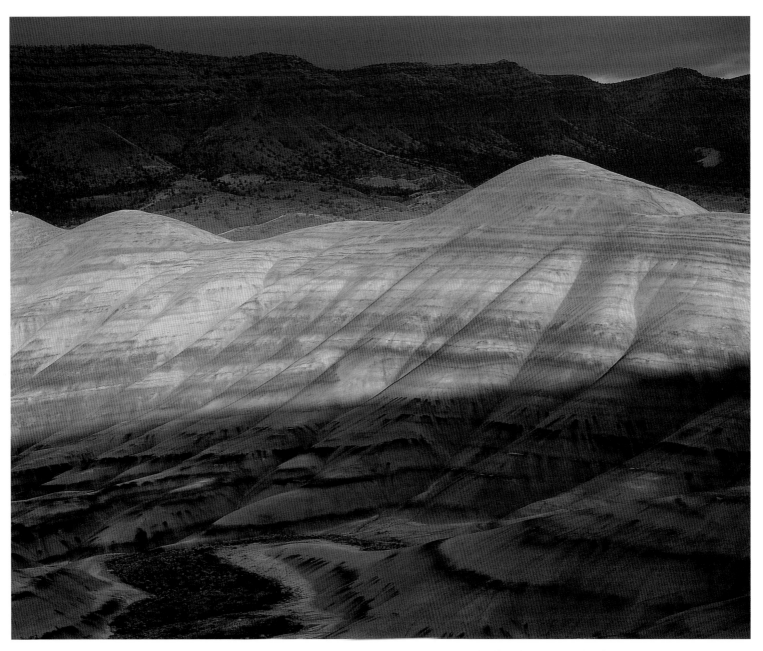

Dave Schiefelbein

Painted Hills, John Day Fossil Beds National Monument, Oregon

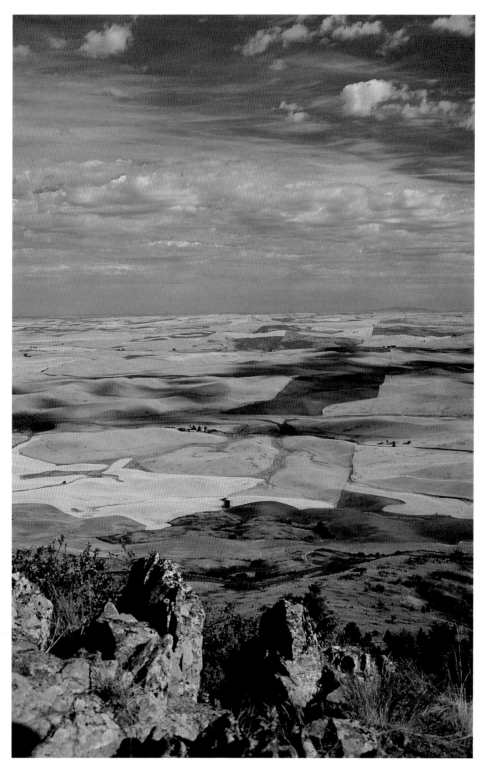

Paul Jacobson *Steptoe Butte, Palouse Region, Eastern Washington*

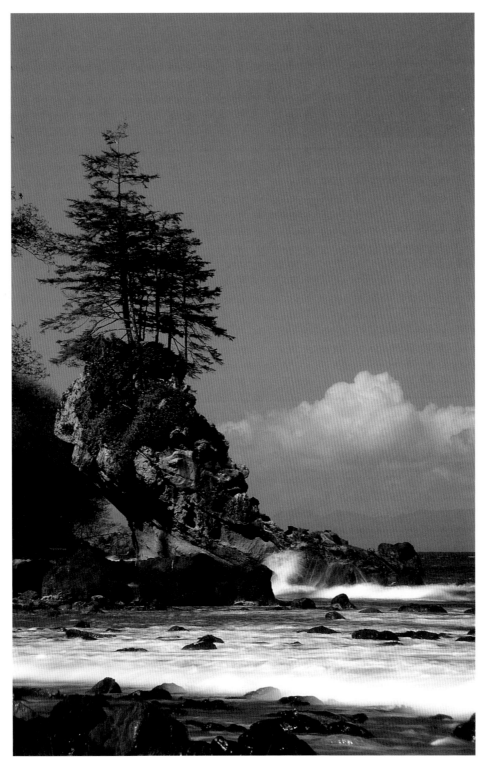

Joe Poehlman *Neah Bay Beach, Strait of Juan de Fuca, Washington*

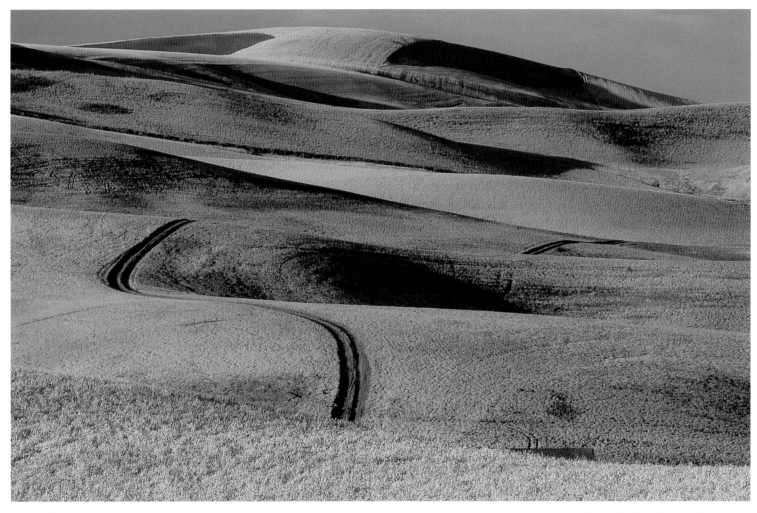

Ron Mellott

Palouse Region, Eastern Washington

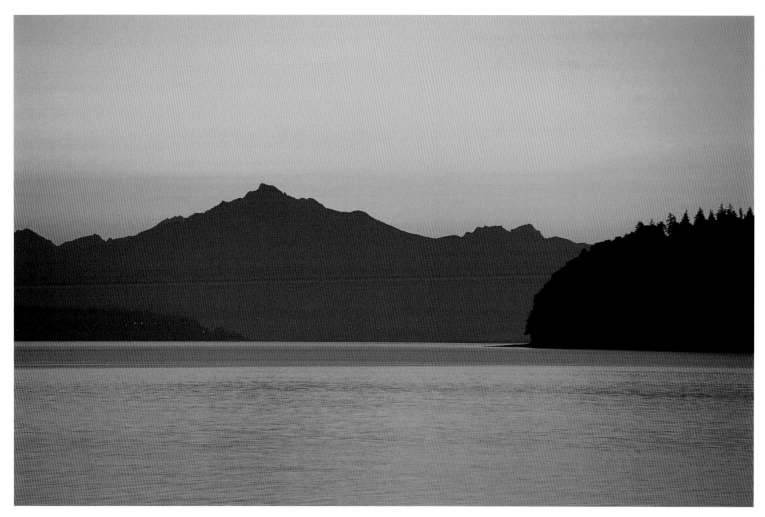

John Hinkey

Sunrise, Puget Sound, Washington

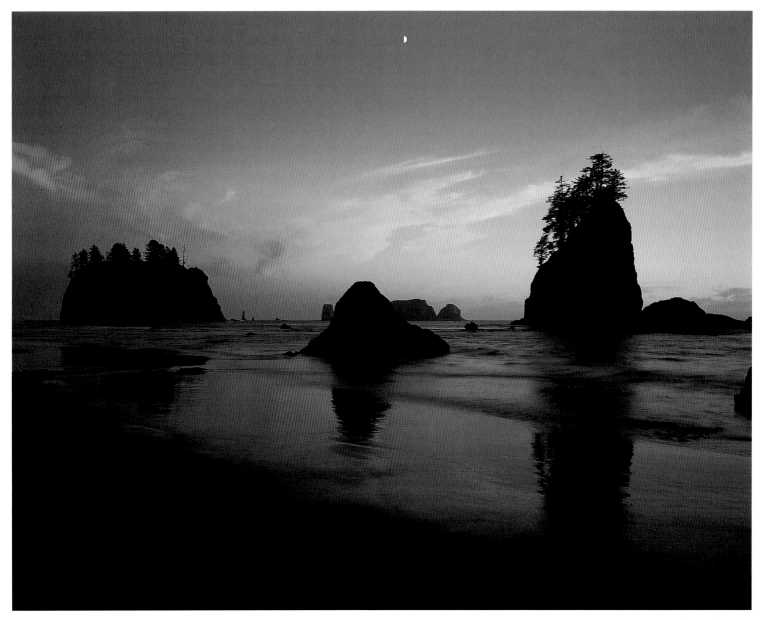

Mark Windom

Second Beach, Olympic National Park, Washington

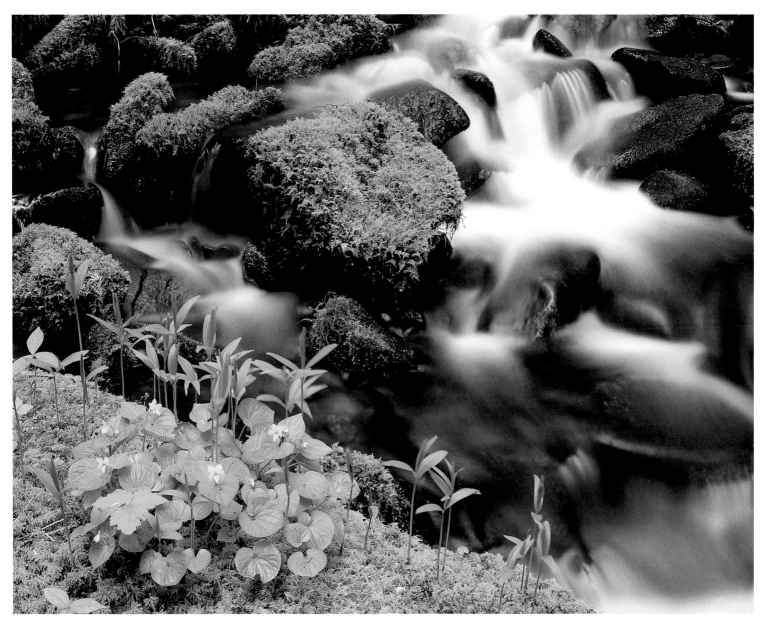

Ron Mellott

Stream Violets, Olympic National Park, Washington

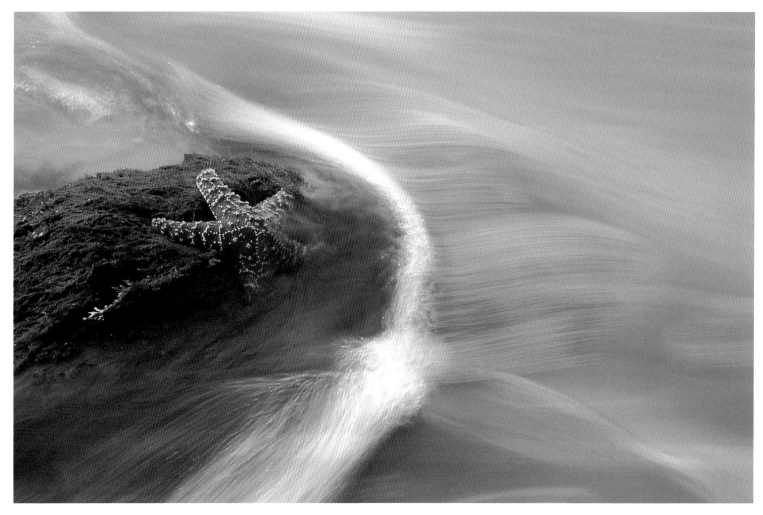

Ineke deLange

Incoming Tide, Crescent Beach, Oregon

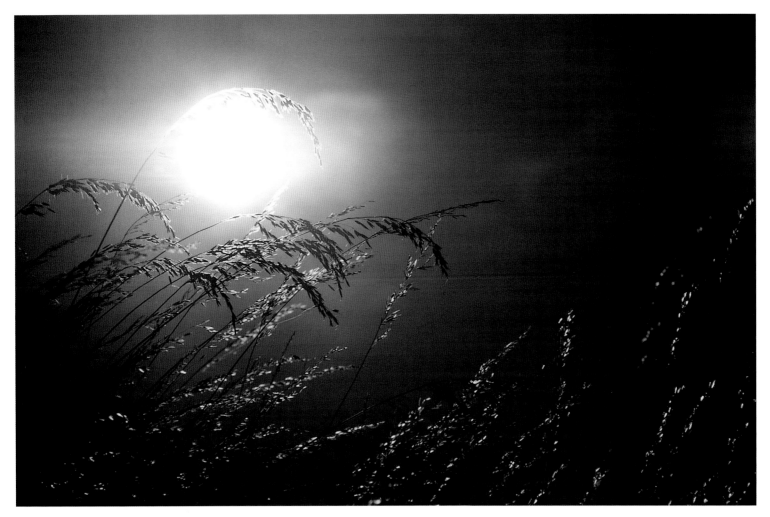

Ron Mellott

Sunset, Blue Mountains, Oregon

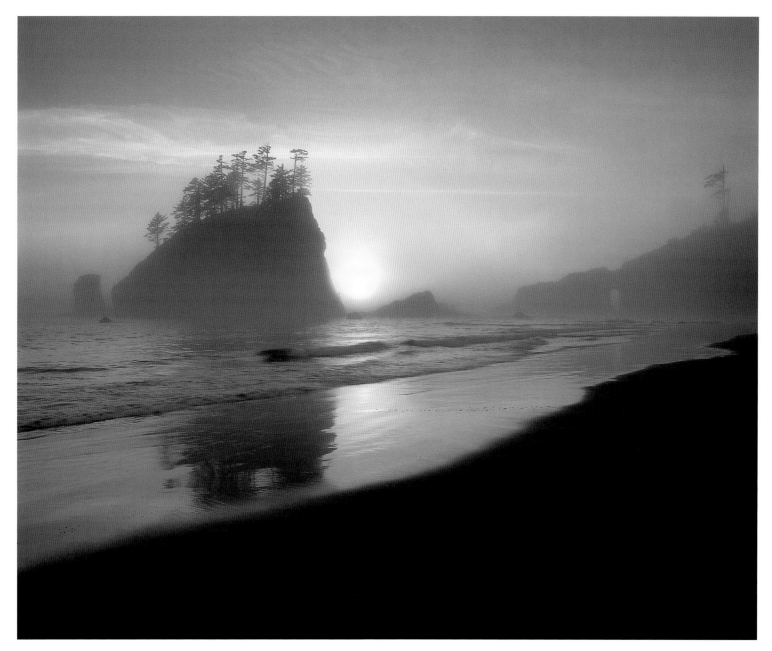

Stephen Matera

Sea Stacks, Second Beach, Olympic National Park, Washington

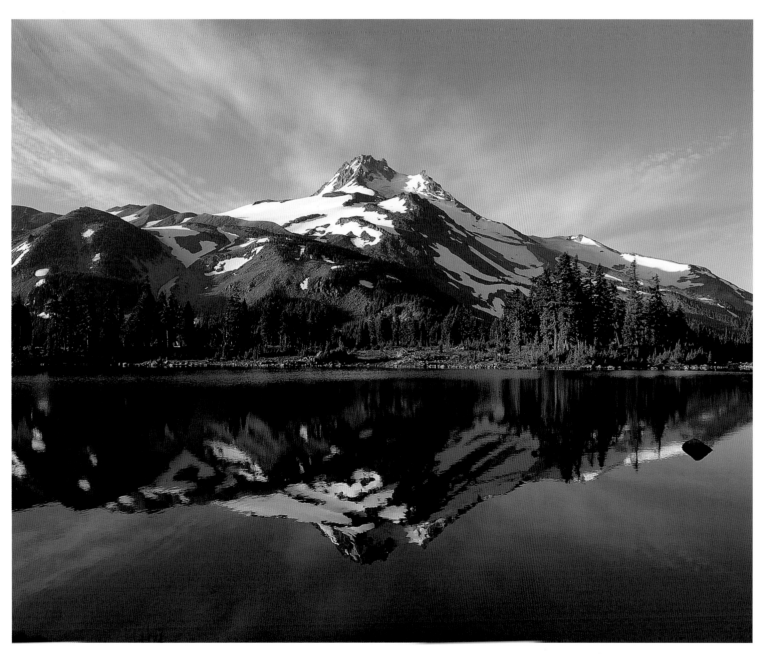

Dan Sago

Mount Jefferson and Russell Lake, Oregon

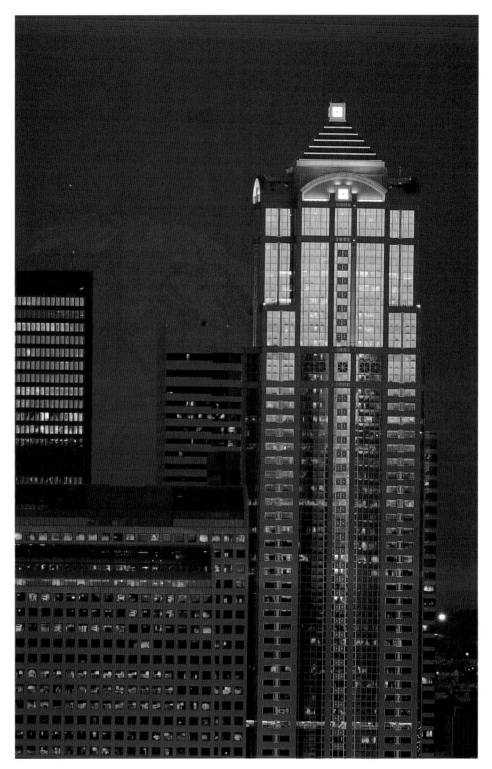

Gary Benson

Seattle and Mount Rainier, Washington

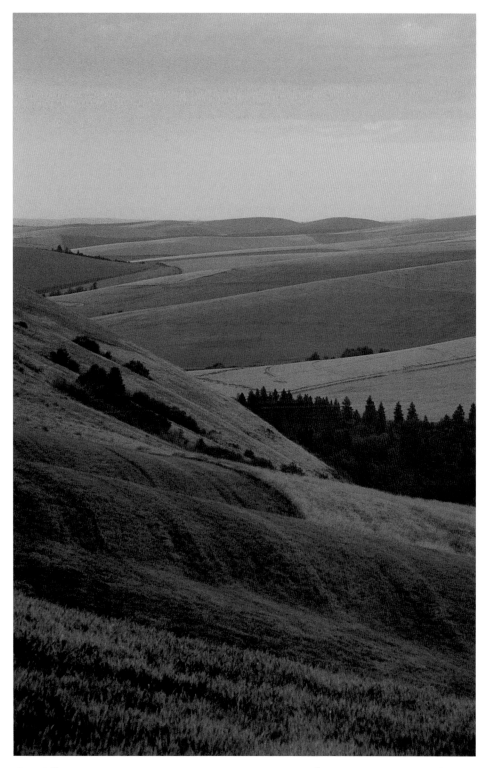

Greg Adler

Palouse Region, Eastern Washington

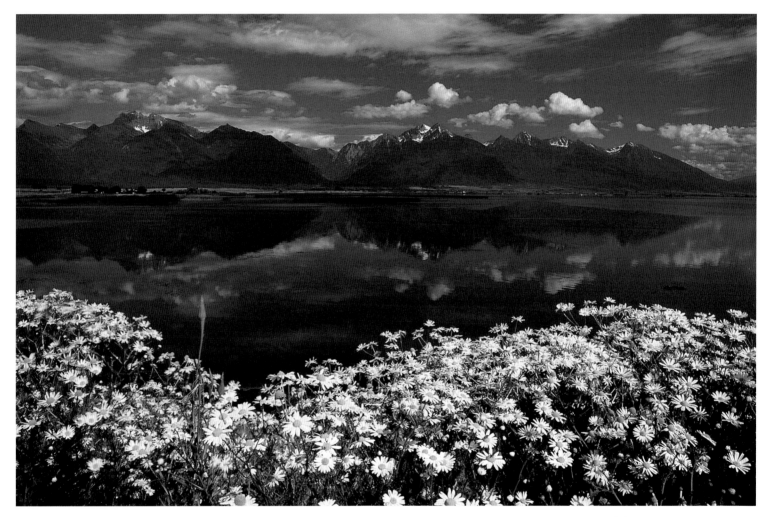

Slavomir Dzieciatkowski

Oxeye Daisies and the Mission Range, Montana

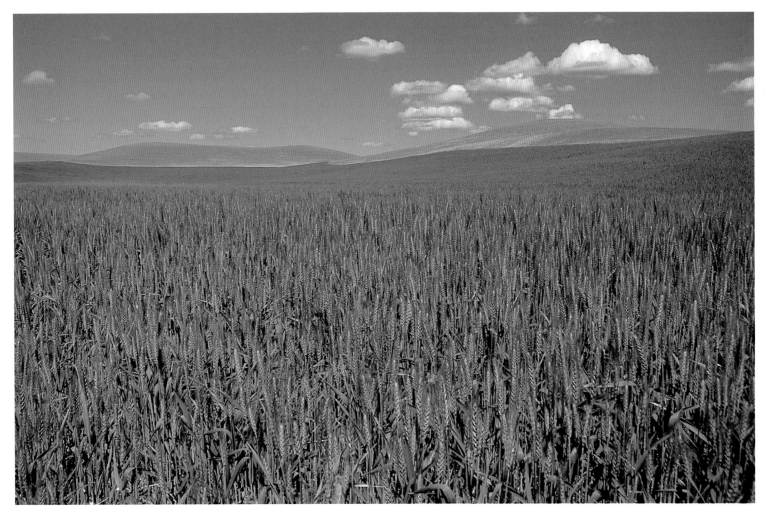

Matthew Cedergreen

Palouse Region, Western Idaho

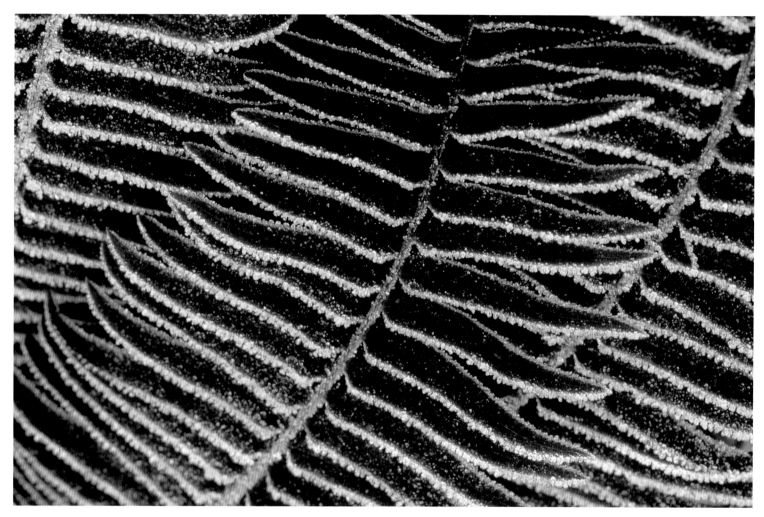

Ineke deLange

Frosted Ferns, Lake Quinault, Olympic National Park, Washington

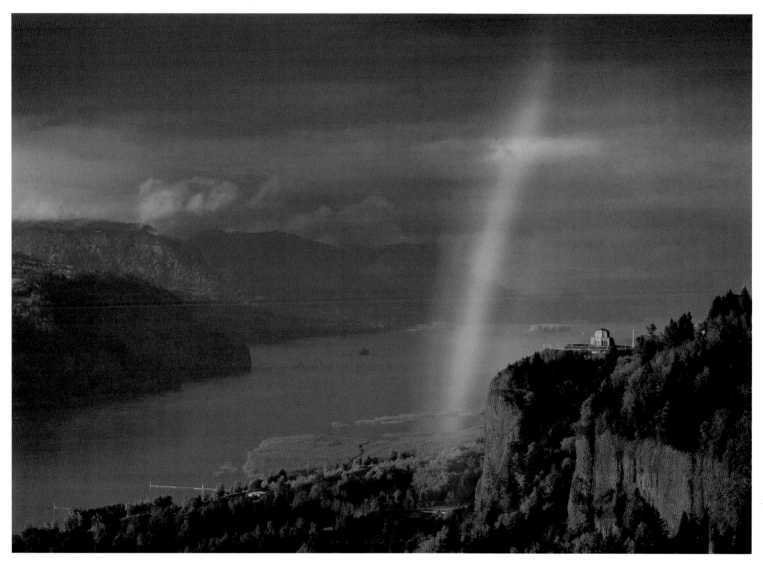

Bill Brooksher

Evening Shower, Columbia River Gorge, Oregon

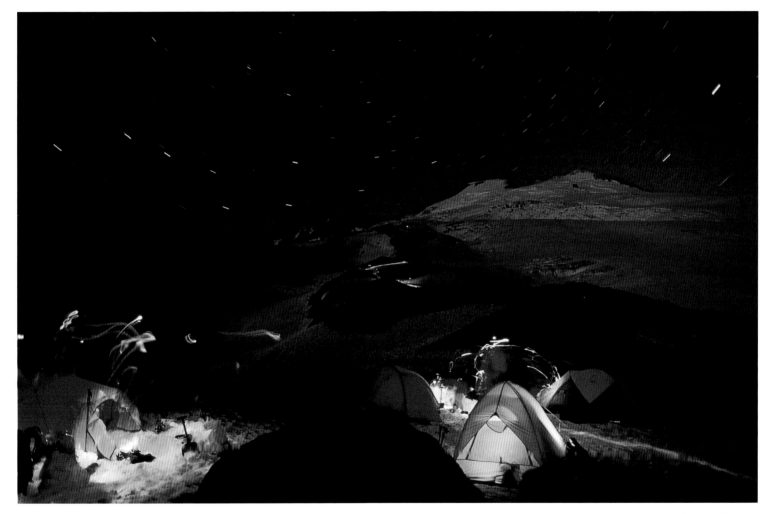

John Hinkey

Snow Camp, Mount Baker, Washington

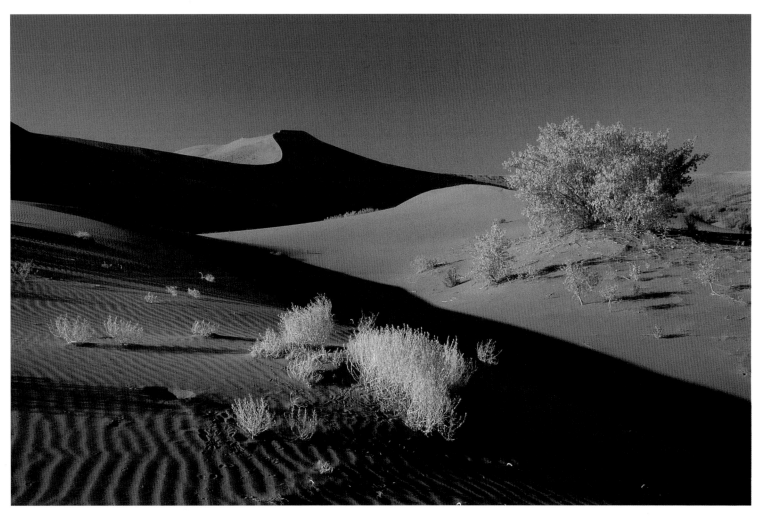

Daniel Kencke

Bruneau Dunes State Park, Idaho

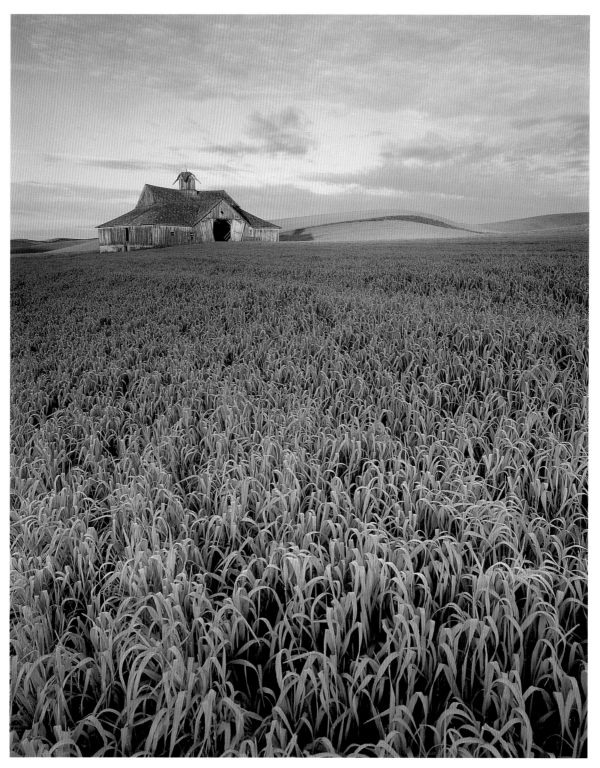

Dave Schiefelbein *Wheatfield at Sunrise, Palouse Region, Eastern Washington*

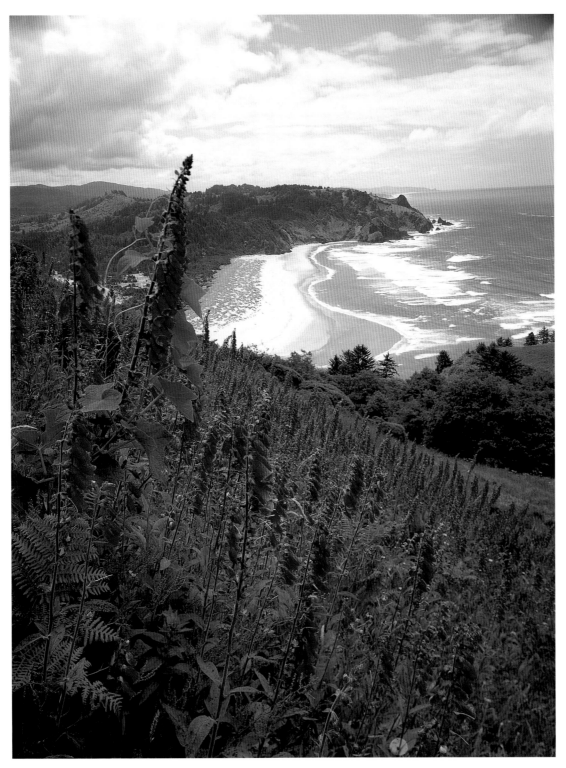

Chris Hauth

Foxglove, Cascade Head, Oregon

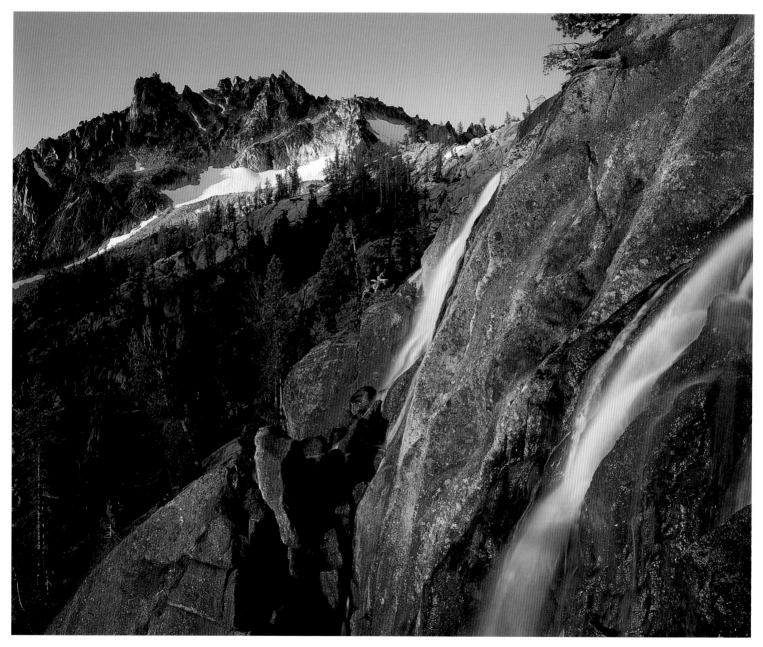

Stephen Matera

McClellan Peak, Alpine Lakes Wilderness, Washington

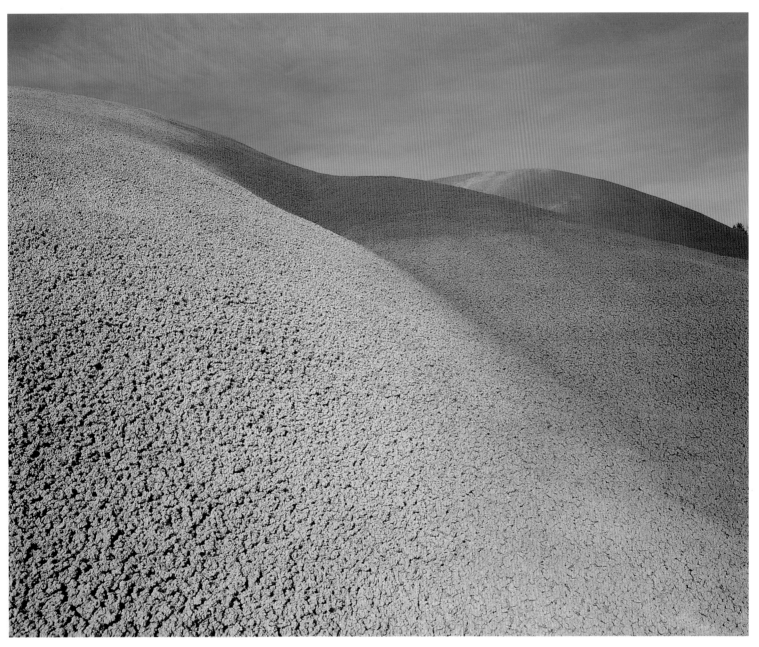

Mark Manack

John Day Fossil Beds National Monument, Oregon

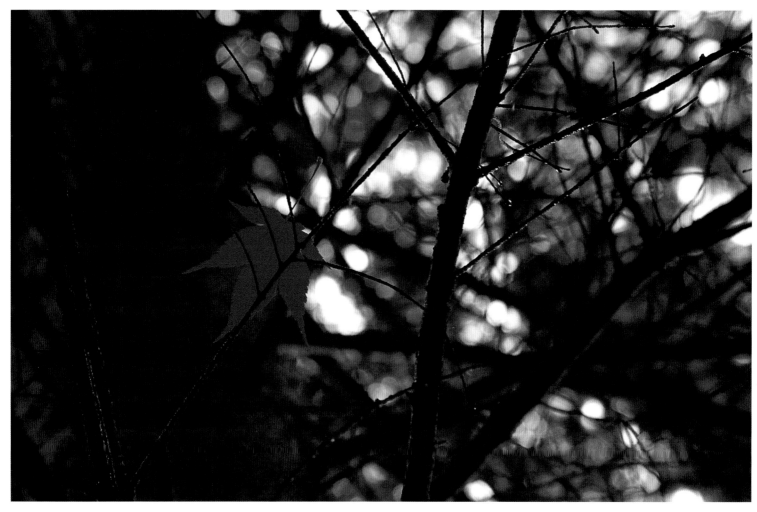

Patrick Hungerford

Red Leaf, Olympia, Washington

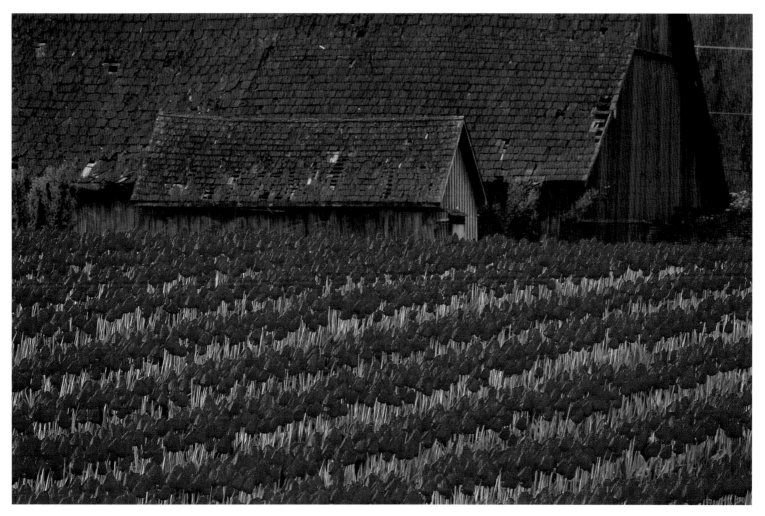

Burns Petersen

Tulips and Barn, Skagit Valley, Washington

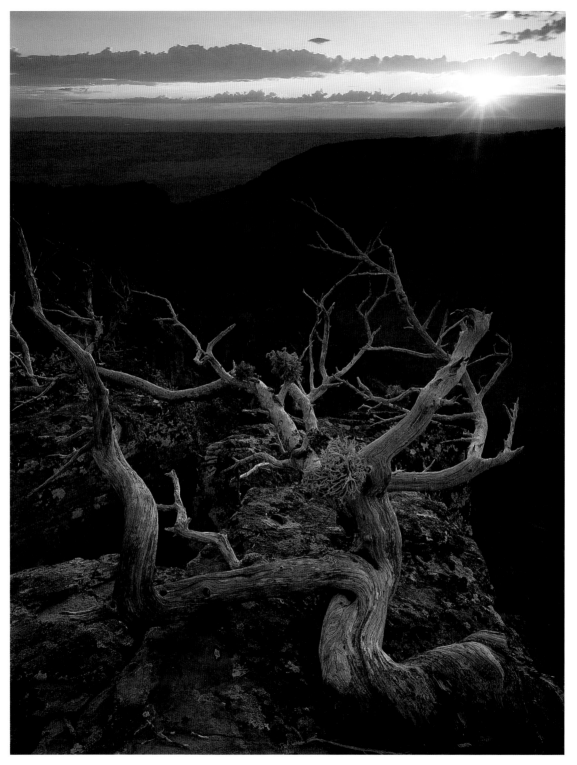

Chris Hauth *Steens Mountain, Southeast Oregon*

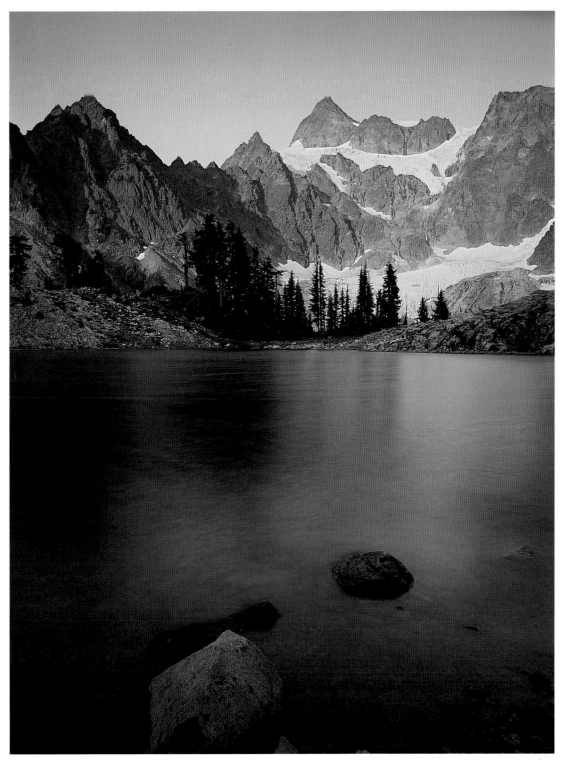

Greg Adler

Lake Ann, Mount Shuksan, Washington

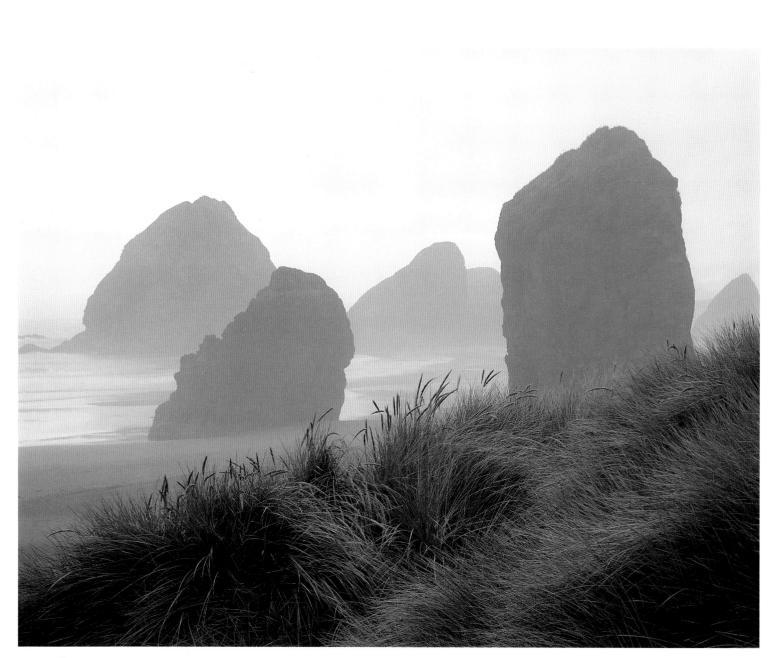

Ron Mellott

Cape Sebastian, Oregon

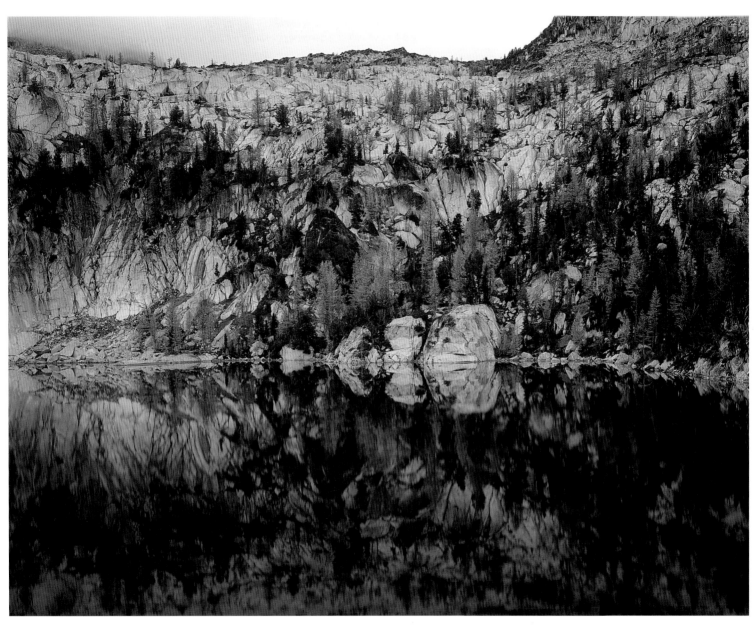

Jeffrey Miller

Lake Vivian, Enchantment Lakes Wilderness Area, Washington

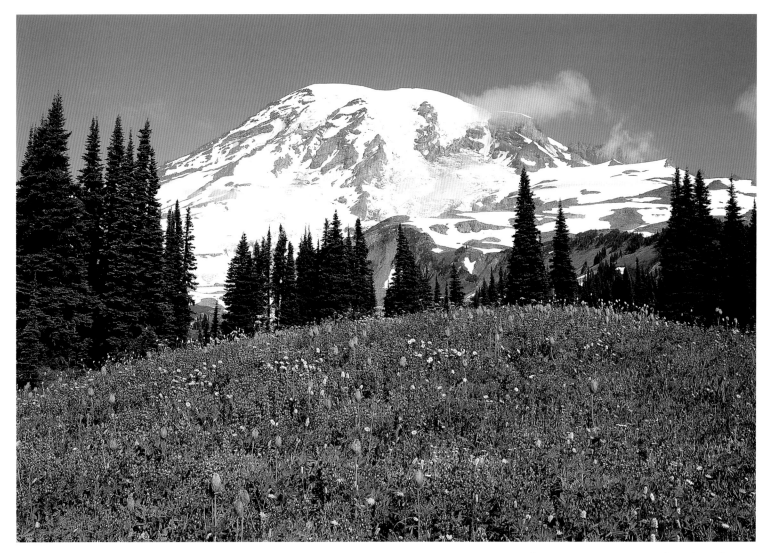

Mark Windom

Mazama Ridge, Mount Rainier National Park, Washington